The Untouchable Tree

An Illustrated Guide to Earthly Wisdom & Arboreal Delights

Peter C. Stone

Skyhorse Publishing

For my parents

Skyhorse Publishing books may be purchased in bulk at special discounts for sales promotion, corporate gifts, fund-raising, or educational purposes. Special editions can also be created to specifications. For details, contact the Special Sales Department, Skyhorse Publishing, 555 Eighth Avenue, Suite 903, New York, NY 10018 or info@skyhorspublishing.com.

www.skyhorsepublishing.com

10 9 8 7 6 5 4 3 2 1

Library of Congress Cataloging-in-Publication Data

Stone, Peter C., 1955-
 The untouchable tree : an illustrated guide to arboreal delights / Peter C. Stone.
 p. cm.
 Includes bibliographical references.
 ISBN 978-1-60239-338-7 (alk. paper)
 1. Trees. 2. Trees--Symbolic aspects. 3. Trees--Pictorial works. I. Title.
 SD383.S86 2008
 582.16--dc22
 2008020836

Frontispiece: *The Valley Spirit*; American Linden, Basswood, Lime (*Tilia americana*)
Photography: Ned Manter and Giclée Café

Printed in China

CONTENTS

ACKNOWLEDGMENTS

This book is greatly inspired by the wisdom and traditions of many indigenous peoples, from whom, I believe, we have so much to learn. I am indebted to the enduring strengths and truths of those cultures.

I am ever grateful to my family, Amanda, Sara, and Oliver, who support my field trips and studio sorties at all hours with unceasing love. And to my parents, who have always shared with me their love of "green things that grow."

Many thanks to those friends who read the manuscript and kindly offered their insights at various stages: Theresa Cederholm, Peter Dean, Terry Freiberg, Margie Baldwin, Chrissie Bascom, Harrison Condit, Phoebe Perry, Karie Vincent, and Marcella Hague Matthaei for her fervent support of the story in an early form.

It would not have found a publishing home without the continued encouragement and literary representation of Meredith Hays and Stephany Evans.

My editor, Bill Wolfsthal, energetically offered the fertile ground from which the book could come to life, nurtured gently in design and clarity by Abigail Gehring and Sarah Van Bonn.

To that beginning, I appreciate the efforts of Carolyn Weston at the Massachusetts Horticultural Society. I also thank Chris Bryant, Jessica Whittaker, and the directors of the Sippican Lands Trust for their shared interest and commitment to the untouchable trees of Sippican.

And most importantly, to the trees that have given so much without asking anything in return: I am blessed not only by your grace, but by the technologies you have made possible and the "practical" materials you have provided: the paper and inks with which this book is printed; my easel and chair, brushes and stretcher frames; the turpentine, linseed oils, varnishes, and vehicles of these oil paints, all of which are recycled daily in both field and studio. I have tried to make use of them wisely and prudently. I hope I have not let you down.

Author's Notes

Each species of tree depicted herein is accompanied by a second narrative. This second piece includes notes that highlight "hidden" or secondary images within the artwork, pointing out a range of cross-cultural, illustrative, historical, and mythological symbols in the context of common North American trees. The content deliberately reaches beyond North America and across cultures because it addresses the "untouchable" aspect of ourselves found in all things and the important context that our humanity gives to the applications of the sciences.

The second narrative also offers pertinent sources, insights, and quotations that may be used by educators to spearhead discussions.

Some of the paintings draw upon inspirations from belief systems and cultures

beyond my own. To many of them, I consider myself an outsider. Thus, I lay no claim to accurately representing their interests or their perspectives on the traditions with which I have been raised, for it is undeniable that true understanding of an indigenous culture can only come from the voices of that culture.

Issues associated with land use, resource allocation and development, conservation, environmental destruction and preservation, and tribal lands programs arise from all backgrounds and histories of contemporary life. However, it is important to recognize the individuality of indigenous belief systems so that any society doesn't subordinate them into whatever dominant attitude might be deemed most acceptable at the time.

Cultural pollution has led to an alarming loss of languages and evolutionary knowledge around the world, and needs to be addressed along with pollution of the environment.

The goal here is to appreciate and learn from the traditions of indigenous peoples, from their uncorrupted wisdom and unsentimental truths.

FOREWORD

Since the daybreak of history, when Homo sapiens had long enjoyed the benefits of blossom and fruit, wood and shelter, the tree has grown into a cross-cultural symbol of abundance, life, and of God. The Tree of Life, the Tree of Knowledge, the *axis mundi*, the Flowering Tree, the Tree of Wisdom, the Sacred Tree—this largest plant on earth represents the mythological axis, the unifying aspect of all humankind that is the divine spark of the Godhead within us.

It forms consecrated groves and sanctifies resting walls and burial grounds. It is hallowed as the banyan for Hindus, and the pipal or bo tree for Buddhists. Revered as the japonica at Shinto shrines in Japan, it also serves as a metaphor in Taoist philosophy for the tranquility necessary to accompany activity, often depicted

as a great rooted tree by a flowing river. The giant ash of Nordic myth, Yggdrasil, signifies the boundary between the earthly and the divine, as does the Lote Tree for Muslims.

Through ancient times, the pomegranate provided the forbidden fruit for the Persians and Jews, and the Cedar of Lebanon was known in art and literature as an emblem of power and long life. For the Yucatan Mayas, the blessed *yaxché* upheld the layers of the sky. In Egypt, twin sycamores were thought to guard the eastern gate of heaven through which the sun god Ra appeared each dawn; and a branch from the evergreen date palm represented the deity Heh, the mythic personification of eternity.

> "Trees are the earth's endless effort to speak to the listening heaven."
>
> —Rabindranath Tagore

In fact, trees have always been used to symbolize deities. For the Greeks, the oak was thought sacred to Zeus, while the myrtle characterized Aphrodite, and the olive, Athena. In earliest Gaul, the evergreen *ilex*, with holy white flowers and red berries, began giving its spiny leaves called "holly" to decorate altars and churches. The yew was an emblem of immortality, and the hazel was considered a fount of sacred wisdom by Druid priests. The Druids even derived their name from the venerable oak, whose interior was thought to be the abode of the dead.

But if that is so, what happens to trees when *they* die?

Beyond the magical cycle that transpires daily before our eyes, of aging to death to decay to soil to seed to sprout to sapling, trees have provided a major source of energy since the industrial revolution. Coal was created from the detritus of the Carboniferous forests over three hundred million years ago. It was that period which gave rise to three

major classifications: tree ferns of the tropics and sub-tropics; the conifers, cycads, and ginkgo; and all flowering plants, which include most trees.

"I am myself and what is around me, and if I do not save it, it shall not save me."

—José Ortega y Gasset

As hunter-gatherers, Homo sapiens began to consume trees for a wide range of uses: building materials, edible fruits and nuts, medicines, fuel, weapons, tools and utensils, woven fabrics, dies, spices, charms and ornaments, and all manner of lumber and paper products. Earth goddess cultures found a sustainable equilibrium, often managing woodlands to benefit hunting or planting needs, but the agricultural revolution spread across continents, followed more recently by the industrial revolution; with them swelled our gluttonous appetite for arboreal materials. Many of the great stands of timber have been devastated since the time of the Assyrians in the Mediterranean region, and still we continue our reckless harvests despite the well-documented impact on the planet's climate and ecology.

Instead of taking a holistic or long-term view, we have grown attached to our fleeting conveniences. Beholden to our sciences and technologies while ignoring the importance of our humanity, politicians and special interests seek new sources for oil, gas, and timber in places that were once sanctified; in North America, the lands taken from aboriginal peoples, and later set aside for national parks, forests, and the Arctic National Wildlife Refuge, are under siege.

Can we change the way we think?

With the photosynthetic capacity for transforming carbon dioxide into oxygen, the tree is an obvious and integral element of our biology—yet often disregarded. By its

seemingly infinite variety of forms connecting us to the realms of nature, the tree also plays a vital part in fostering our inner selves.

This book wasn't written to glorify the tallest of the majestic redwoods, or exalt the girth of the Mexican swamp cypress, or pay homage to the enduring bristlecone pine that is over forty-five hundred years old. Any of these specimens would have been welcomed in the Hanging Gardens of Babylon, one of the Seven Wonders of the World.

Rather, this book was created to show a variety of ways we might think outside our cultural box in viewing an unremarkable grove of swamp maple, a modest copse of oak, or an undisturbed stand of hemlock. These are just as precious; each really does offer us a unifying view of the forest . . . for the trees. Each has the power to recall the sacred feminine, the mothering aspect of the energies that inform us—that sensitivity and respect for our balance with the planet that sustains us.

"Only God can make a tree, true enough, but I'd like to see Him paint one."

—Maxfield Parrish

This wisdom is nothing new, just ignored or forgotten. A nineteenth century Wabanaki Algonquin called Bedagi (Big Thunder) said, "The Great Spirit is our father, but the earth is our mother. She nourishes us; that which we put into the ground she returns to us . . ." Two thousand years ago, Lao Tzu wrote, "Know the masculine, keep to the feminine . . ."

It is knowledge older than history.

Any book about trees can't help but be a book about people, so this story ventures to question our place in nature, in light of the unarguable truth that we are

nature, too. One way to make that connection with the mystery in our lives is to discover the vast range of symbols revealed by those whom many cultures indigenous to North America call the Standing People, symbols that can enable us to see familiar things with fresh eyes. In essence, that means allowing ourselves to actually learn from trees, to change the way we view the world and change our dream of how the world should

Tat tvam asi…

Thou art that.

—*Chandogya Upanishad,*
Chapter VI

be. But instead of attempting to cover the mythologies of the innumerable species inhabiting the globe in a single volume, the intent here is to celebrate a feature of some common North American trees that is frequently overlooked: their unassuming role in nurturing the human spirit and, in doing so, this earth.

The scent of a blossom or the hue of brilliant foliage has the power to elicit a reaction of pure wonder. If we allow ourselves to stop, how many times might we gaze and utter, "God, how awesome!"

In the wisdom of mystics and sages, such a simple act has for millennia been one of participation . . . in divinity. When we open ourselves creatively to it, the nurturing power of trees also becomes a healing power for the landscapes and life forms on which we depend; the humane gives context to applications of the sciences and a reason for a new vision of the world. And if this prompts us to question our pivotal responsibility for every ecosystem, to learn from the goodness of cultures that still understand how to live in accord with land and sea and sky, then it might even be confirmation that *God* (or whatever name you wish to apply, whatever your belief system) is the meaning of *good*.

Thus, we have a chance to realize that the spark of divinity in us also lives within the untouchable tree.

Blossoms

When the seed dies, the earth is wounded.

But only in resurrection.

For soon a small green sprout springs forth, round as the moon,

another axis of this bountiful, troubled planet.

If anything, that is good. ❧

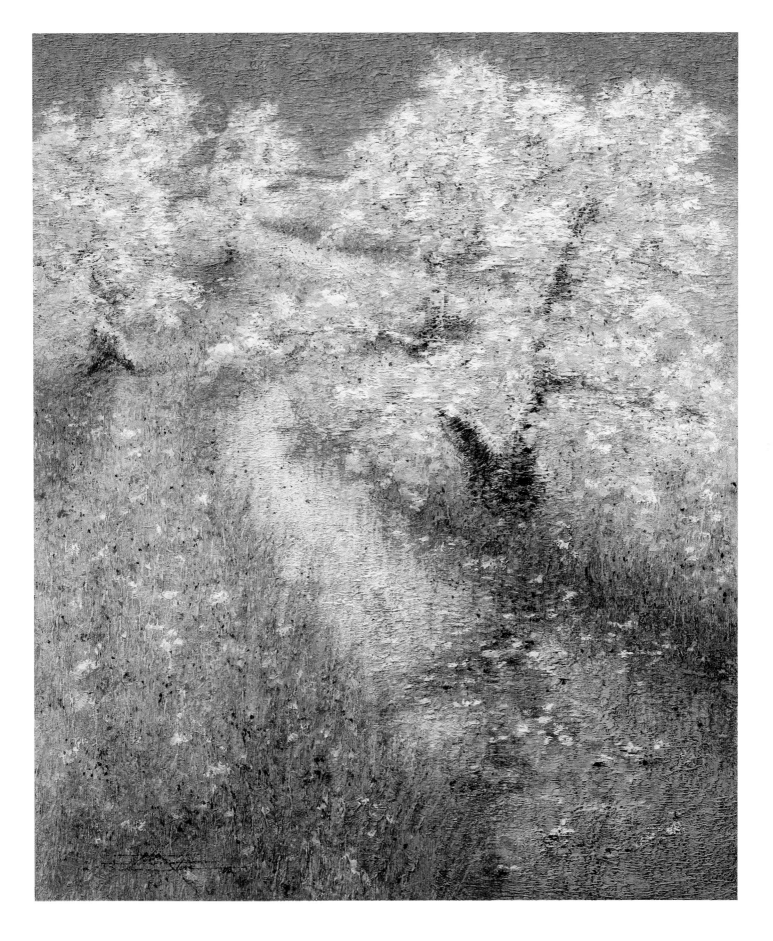

BLACK CHERRY (*PRUNUS SEROTINA*)

Ω

Black Cherry (*Prunus serotina*): An emblem of immortality in Chinese lore, the blossoms are associated with maidens, while the wood is thought to ward off malevolent spirits.[1] In other traditions, the naked cherry (in winter) represents deception,[2] possibly because its fleeting seasons of alluring flower and fruit turn frigid so quickly. In the foreground, the forked tree often symbolizes the conflicts within us as well as the mythical Tree of Knowledge of Good and Evil. Its delicate scattered petals are a beckoning motif in this context, one that entices us to embark on a new journey by following the watery path of the sacred feminine.

 If you look into the distance, the serpentine stream rises up as the subtle head of a snake. Water is linked with fertility and life, while the snake appears in most traditions—although with a wide range of negative and positive connotations. It is

intimated here for its connections to the powers of rejuvenation and healing, and for its knowledge of mysterious things. White, blue, yellow, red, and black are splattered throughout the landscape because they are linked with the "endless" snake found in Navaho sand paintings, *klish-do-nuti'i*, who is daubed with these sacred colors tied to the cardinal directions for many indigenous peoples of North America.[3]

The mythological adventure always begins with an inner calling, a whisper, a blooming of awareness, even a curious stream that summons us to break away from the safety of a well-trod path. Streams beget rivers, unrivaled cross-cultural symbols of journeys and characterized by movement and stillness, representing the temporal and eternal aspects of our lives. The river, rejoices Kenneth Grahame in *The Wind and the Willows*, is a ". . . babbling procession of the best stories in the world, sent from the heart of the earth. . ."[4] "What it hasn't got is not worth having, and what it doesn't know is not worth knowing . . ."[5]

Who knows how and where its descendants may travel?

Do we welcome them?

Its children waltz off like cherry blossoms on the wind.

Rambunctious cousins join the sweet circus of wild pears,

the apple orchards' deft ballet. ❧

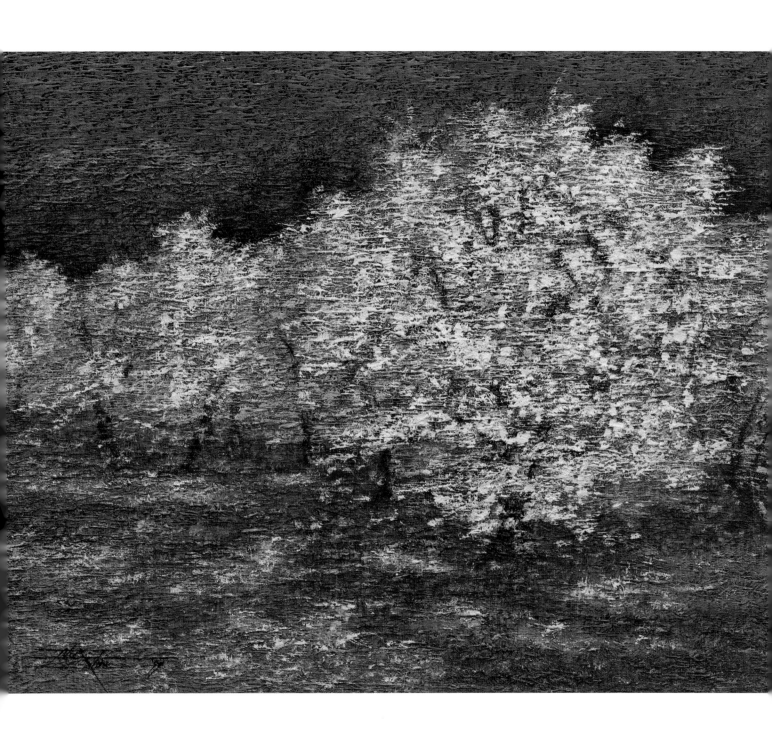

COMMON APPLE (*MALUS COMMUNIS*)

Ω

C ommon Apple (*Malus communis*): I've painted many old orchards in the spring, when the crests of distant hills, like one's dreams, no longer seem so unattainable. But visions such as this one, and certainly dreams, are able to access ". . . a mythological past that still exists parallel in time to present–day ordinary reality . . ."[6] It is a past and present familiar to aboriginal cultures around the world. To indigenous Australians, for example, it is aptly known as "the Dream Time."[7]

During this particular afternoon, the leaden skies broke apart as sunlight splashed down upon the fertile green grass through the laughing blossoms that might denote one's uplifted sentiments. (If you look closely into the foremost tree, the luminous shadows become a delighted profile.) With the enormous diversity of apples available today (about 7,500 varieties around the world, a third of which are grown

in the United States[8]), those delicate blooms and their mysteries may also represent a fascinating blend of art and science, and the meaning of horticulture: "The science or art of cultivating fruits, vegetables, flowers, or ornamental plants."[9]

But should we be wary of how we apply our sciences, often using specialized technologies to reap short-term rewards from natural resources? Why bother questioning how we treat a simple orchard?

Consider pesticides, for example, and the bees that pollinate this grove; without them, the trees would bear no fruit. "Bees play an integral role in the world food supply, and are essential for the pollination of over ninety fruit and vegetable crops worldwide, with the economic value of these agricultural products placed at more than $14.6 billion in the U.S. In addition to agricultural crops, honey bees also pollinate many native plants within the ecosystem."[10]

Yet, for many years, our industrial agricultural system has been pumping large amounts of antibiotics and pesticides into the air, soil, water, and trees. And not just in the United States. Almost five decades ago, chronicles journalist Laurie Garrett, "The Green Revolution—a World-Bank-backed scheme to improve Third World economies through large-scale cash crop production . . ."[11] transformed "… thousands of acres of formerly diversely planted and fallow land into monocultured farms for export production of coffee, rice, sorghum, wheat, pineapples, or other cash crops. . ."[12]

"When an area had very diverse plant life, its insect population was also diverse and no single pest species generally had an opportunity to so dominate that it could destroy a crop," Garrett continues. "As plant diversity decreased, however,

competition and predation among insects also declined. As a result, croplands could be overwhelmed rapidly by destructive insects. Farmers responded during the 1960s with heavy pesticide use, which often worked in the short term. But in the long run pesticides usually killed off beneficial insects, while crop-attacking pests became resistant to chemicals. A vicious cycle set in, forcing use of a wider assortment of insecticides to protect crops."[13]

The result was a boon to pesticide and fertilizer manufacturers, a plausible reason why ". . . the collusion between U.S. agencies and the big businesses . . .,"[14] in the terms of author John Perkins, has carried on to the present, at home and abroad. Meanwhile, the local farmers have been left to contend with the often disastrous long-term consequences. "In some Third World countries," assesses Paul Hawken, "pesticides kill more people than do major diseases."[15]

> Spherical in form, the apple is a classical symbol of totality.

Looking back to this orchard, could some of the antibiotics and pesticides we use in United States also end up in the bees, contributing to the Colony Collapse Disorder (CCD) that is wiping out bee colonies around the country? Among the likely factors first suspected of causing the disorder are ". . . mites and associated diseases, some unknown pathogenic disease and pesticide contamination or poisoning."[16]

"We're asking a lot of our bees," concludes author Michael Pollan. ". . . That seems to be a hallmark of industrial agriculture: to maximize production and keep food as cheap as possible, it pushes natural systems and organisms to their limit, asking them to function as efficiently as machines."[17]

If the stresses on the bees lead to stresses on the apple trees, do we need to rethink our agricultural practices? "What agrarian principles propose," writes Wendell Berry, ". . . is a revolt of local small producers and local consumers against the global industrialism of the corporations. Do I think that there is hope that such a revolt can survive and succeed and that it can have a significant influence upon our lives and our world?"[18]

Berry answers himself with a hopeful "Yes."[19]

To rethink or revolt, we can start by asking what we should see and hear in a *healthy* grove, by observing the whole interconnected system and remembering what kind of environment bees must have for vigorous productive colonies. We might even look for the symbols of that healthy environment growing right before our eyes.

In this orchard, the dominant palette is fittingly built of whites and blues and greens, inspired by direct observation of nature. It is no coincidence that these hues are viewed as feminine by indigenous cultures of North America, while red, yellow, and black are viewed as masculine.[20]

Then there's the apple itself. Spherical in form, the apple is a classical symbol of totality.[21] It has long stood as an emblem of love in numerous traditions, predating its fame as the sweet food of temptation in the Garden of Eden or a dream symbol of sexual pleasure.[22] But its connotations include that of knowledge in Celtic lore and the representation of eternal youth in Norse mythology.[23] Perhaps these are reasons why, from Europe to Asia, blossoming fruit trees were used in ancient fertility ritual and treated with the concern and tenderness accorded a woman expecting a child.

Does any being really know?

The lindens seem to. They buzz with the gossip of bumbling bees, of staggering butterflies drunk with pollen, each upon its blissful path.

Swamp maples laugh gaily with choirs of peepers, chirruping swallows, worming red robins and nesting brown wrens. ❧

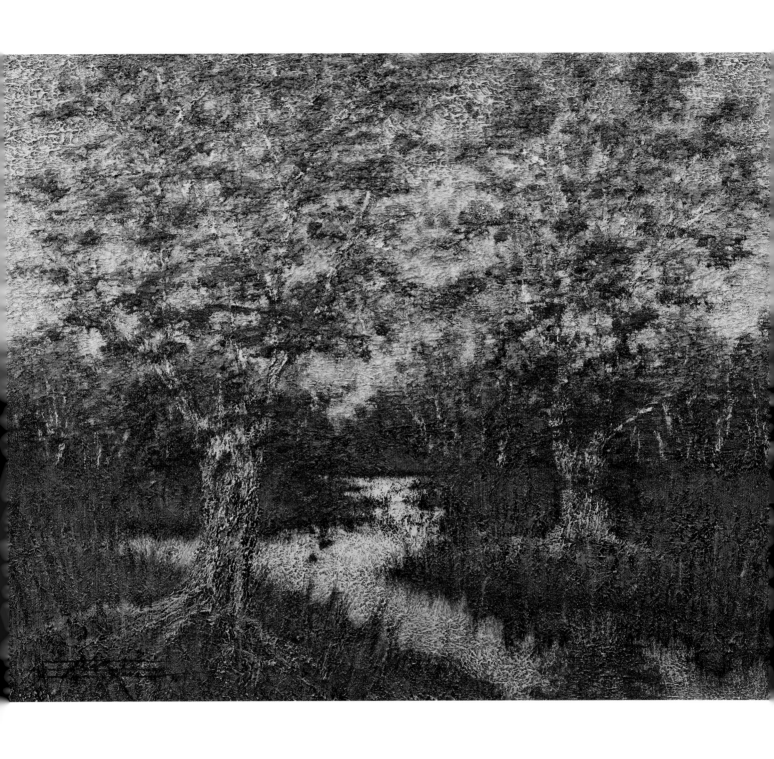

RED MAPLE, SWAMP MAPLE, WATER MAPLE (*ACER RUBRUM*)

ॐ

R ed Maple, Swamp Maple, Water Maple (*Acer rubrum*): Bright as scarlet roses and ablaze with the color of vitality and desire, these fiery maples form a threshold through which anyone might follow a path that reflects the heavens or some hallowed feminine voice. Even if it leads through one's personal morass, the species is often considered one of reserve. The ground may be damp, but water is the unifying element depicting our emotional nature, just as blue represents wisdom and clarity in many cultures, a hue that might lead to Truth.

"The blue of changing skies," reflects the eloquent stained glass master craftsman, Charles J. Connick, "of deep pools, of tiny brooks, waterfalls, glaciers, and the great oceans themselves have an ever-increasing charm for me. Prophets, priests and poets have announced and preached and sung in terms of blue."[24] By example,

he mentions the English poet, John Keats (1795-1821), who celebrates the hue this way: "Blue, 'tis the life of Heaven!"[25]

As with all symbols, we must keep in mind that there are multiple meanings for colors, depending on cultural (and psychological) associations or natural associations, although colors found in nature have timeless implications.

Any color, so long as it's red

Is the color that suits me best,

Though I will allow there is much to be said

For yellow and green and the rest.

—Eugene Field (1850-1895), "Red"[26]

Throughout the landscapes in this book, the significance of the chosen palette is fundamentally natural, followed by its psychological symbolism for enhancing the impact of a painting. Thus, the water here reflects the calming color of a clear blue sky, and may also imply the cross-cultural search for an understanding of the Mystery.

What was all this before creation?

Was there water?

Only God knows,

Or perhaps he knows not. . . .

—*Rig Veda* X, 129[27]

For example, the use of blue paint is sacred for rituals of the Sioux: ". . . the power of a thing or an act is in the understanding of its meaning. Blue is the color of the heavens, and by placing the blue upon the tobacco, which represents earth, we have united heaven and earth, and all has been made one."[28] It fits well in the

triangular patch of sky between the trees, a shape that is symbolic of equality, inner knowledge, and sensitivity for many indigenous peoples.[29] Here, it gives rise to an innocent upturned face, a window on our own sense of wonder.

There are two sides to every view, however, and some may scoff at this visage because of their own interpretations in the same way countless scientific "discoveries" have been ridiculed before being accepted; the observations of Darwin, Galileo, and Heisenberg all met resistance. Yet in exploring the unified field of energy and matter, neuroscientists and quantum physicists concur with the adepts of the science of consciousness developed thousands of years earlier (known in India as *brahma-vidya*, "the science of the Supreme").[30]

> "The fairest thing we can experience is the mysterious. It is the fundamental emotion that stands at the cradle of true art and true science."
>
> —Albert Einstein

This should be no surprise, for scientists now know that the so-called "solid" atoms in stones, wood, or the cells of our bodies are comprised of "more than 99.999 percent empty space," making them "proportionately as void as intergalactic space."[31] The Yoga Vasishtha of ancient India's Solar Dynasty foretells this with the observation, "In every atom, there are worlds within worlds,"[32] implying that physics and mysticism explore the same realms. As physicist Albert Einstein (1879–1955) famously says, "The fairest thing we can experience is the mysterious. It is the fundamental emotion that stands at the cradle of true art and true science."[33]

Still, it is incredible to think how many sacred rituals tied to an intrinsic knowledge about living with the land were demeaned as foolishness or destroyed

by the overtaking "Christian" cultures, especially considering their anthropocentric biases in biblical terms. "Because the foolishness of God is wiser than men; and the weakness of God is stronger than men."[34]

How many were arrogantly branded as "Paganism"?

> *. . . the voice of the Great Spirit is heard in the twittering of birds, the rippling of mighty waters, and the sweet breathing of flowers. If this is Paganism, then at present, at least, I am a Pagan.*

> —Gertrude Simmons Bonnin [Zitkala-Sa] (1876–1938) Dakota Sioux[35]

THRESHOLDS

Dogwoods flutter their ivory petals like eyelashes,

beckoning us to cross our next threshold. ❧

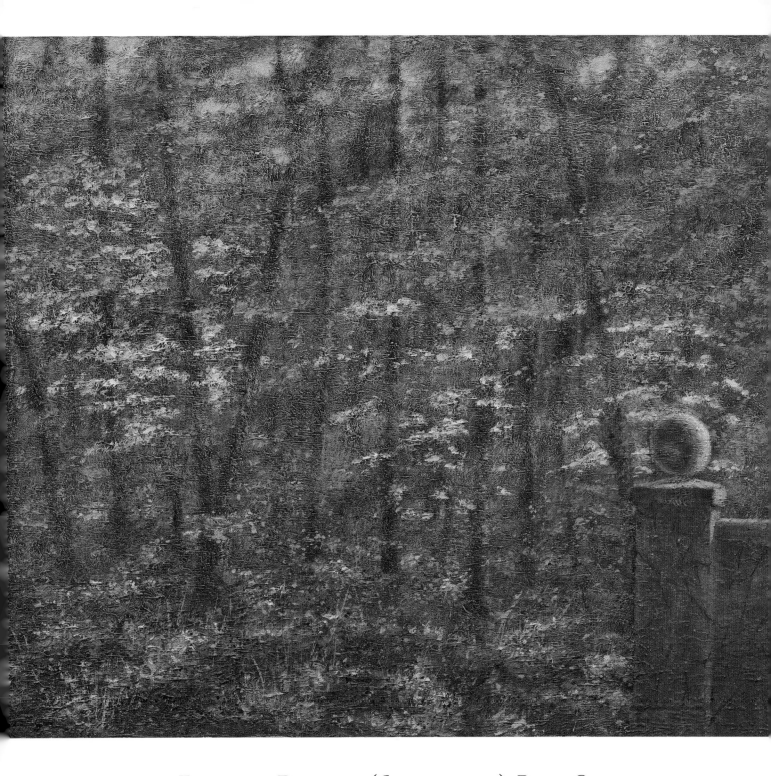

FLOWERING DOGWOOD (*CORNUS FLORIDA*), BLACK OAK

(*QUERCUS VELUTINA*), RED PINE (*PINUS RESINOSA*)

☷

Flowering Dogwood (*Cornus florida*), Black Oak (*Quercus velutina*), Red Pine (*Pinus resinosa*): This architectural gate is no less a threshold for the next stage of one's journey on the Way, though easier to recognize for eyes less tuned to untouched forests. It is a pair of opposites, (like the cherubim with a flaming sword at the entrance to the Garden of Eden, or the terrifying figures guarding some Buddhist temples[36]); one side is in shade and the other in sun, signifying both sides of all our experiences. The crescent moons of transformation atop the pillars also represent the feminine energy needed to balance the masculine energy of the sun, an equilibrium represented in East Asia by yin and yang. But the woods (strewn with this flowering tree representing the crucifixion in Christian traditions[37]— versus "glamour" and "refinement" in Celtic symbolism[38]) are dappled with dogwood blossoms suggesting hardiness in many cultures,[39] even though they give a determined

traveler little clue about which direction to take, what challenges await, or how long one must endure.

The very same questions were faced by King Arthur's Twelve Knights of the Round Table, a symbol linked with "the signs of the Zodiac" and consistent with the Chinese symbol of the sky and the sea or the Dalai Lama's "round council."[40] As Arthur's knights discovered, treading in the footsteps of others creates expectations and may only lead to disappointment or failure on one's quest. The answers come from the truest decisions made within, from one's pure intuition about following one's own path.

For at least 13,000 years (and by some estimates, possibly 14,000 to 35,000) before the Europeans, these woodlands whose white "petals" or bracts caught my eye were managed, hunted, selectively cleared, burned, and thinned by indigenous peoples.[41] "Traditionally, conservationists have regarded people as the problem: people kill animals, eat plants, and in general destroy habitat. But indigenous peoples have spent lifetimes coexisting with the forest, living off the forest while at the same time sustaining a fragile ecosystem by not overhunting its creatures or exhausting its soil."[42]

The answers come from the truest decisions made within, from one's pure intuition about following one's own path.

The Abundant Forests Alliance states that, because of reforestation efforts in the United States, ". . . our forest inventory has grown by 39% over the past half century."[43] This is a good sign, no matter how deforested the country had become since the 1600s when ". . . forests covered about one billion acres, or approximately 46 percent of the United States," according to the American Forest &

Paper Association, compared with about ". . . one-third of the nation—or 747 million acres—. . . still forested today."[44]

The AF&PA goes on to say, "Forest growth has continually exceeded harvest since the 1940s, and today, growth exceeds harvest by 47 percent. Improved forest protection has also made an important contribution to the abundance of forests."[45]

. . . we do possess the technologies and know-how to alter our demands for forest products.

Let's be honest with ourselves, though. How many of these "forests" are really vast monocultures with diminished biota and diversity in every kingdom that once composed the original natural forest, tracts of single species that we shower with pesticides and herbicides to keep down "pests" and "weeds" in the name of economic profits? Is there another way to perceive our idea of "abundance"? Whether or not one views forests as things that *belong* to us, can we continue to renew them in the face of rampant development and population growth and an economic system that creates imbalance in its wake? Can we really regain the balance that once existed here?

After all, we do possess the technologies and know-how to alter our demands for forest products. By our own estimates, "Making new paper from old paper uses 30% to 55% less energy than making paper from trees and reduces related air pollution by 95%."[46] And incredibly, "77% of paper waste generated in offices is recyclable."[47]

Recycling makes economic sense too, cutting the cost of purchasing new paper and of disposing waste, to say nothing of environmental savings. For every ton of paper that isn't recycled, the resources consumed are a shocking part of the *true* cost of that

paper: 17 trees, 275 pounds of sulfur, 350 pounds of limestone, 9,000 pounds of steam, 60,000 gallons of water, 225 kilowatt hours, 3.3 cubic yards of landfill space[48]

But we must keep in mind that recycling will not cut down on greenhouse gases or provide a remedy for the fever of climate change; it is not the same as a sustainable practice with zero emissions. From the standpoint of prominent scientist James Lovelock, known for his vision that this planet is a sort of self-regulating organism, ". . . cutting greenhouse-gas pollution won't make much difference at this point, and much of what passes for sustainable development is little more than a scam to profit off disaster."[49]

Given that dark outlook, why aren't we able to decide on a different approach to the way we view the earth's resources, rather than simply treading in the footsteps of others? If we can change our approach, says environmentalist Bill McKibben, "new technologies and new habits offer some promise. But only if we move quickly and decisively—and with a maturity we've rarely shown as a society or a species."[50]

Are we capable of acting this way? Should we chastise our politicians and political reporters for not responsibly addressing these issues? Or aren't such topics quite so urgent? According to the Chairman of the Intergovernmental Panel on Climate Change, "What we do in the next two or three years will determine our future."[51] Yet, from January 2007 to January 2008, during the U. S. presidential campaign, out of 170 interviews and debates, and 2,938 questions, the "five top political reporters" asked just 4 questions that mention global warming.[52] Only twenty-five questions asked "were related to the issue."[53]

For decades, in fact, we've possessed the scientific capabilities to learn

from extant natural systems and use that knowledge to restore environments. This biomimetic approach has been gaining momentum recently in the commercial world,

> Can we embrace our living planet this way and look at ourselves as part of it, not as a creature outside or superior to its natural rhythms?

due in large part to the work of Janine Benyus, biologist and author of *Biomimicry: Innovation by Nature*, who has "detailed how companies could study nonpolluting, energy-efficient manufacturing technologies that have evolved in the natural world over billions of years, delivering in the process a lesson on the importance of living in harmony with nature."[54]

To learn this way, we need some willpower to break out of the stifling confines of our educational, industrial, and political bureaucracies and allow ourselves to think creatively. In doing so, can we let our compassion motivate us too, not just eagerness for financial gains?

Witness the marvel that is Gaviotas, the dream of Paolo Lugari in the Vichada province of eastern Columbia. Once there were no trees on this barren patch of tropical savanna known as *los llanos*, nor was there was any potable water. But there was Lugari's belief in the power of creative thought and his hope to build a self-sufficient and sustainable eco-village.

Among numerous examples of his commitment to innovation: the introduction of the Caribbean Pine (*Pinus caribaea*) native to Central America,[55] and later, a particular fungus called mycorrhiza (*Pizolithus tinctorius*), a little brown mushroom without which the pines could not survive, that enabled the roots of the pine to absorb nutrients from the red soil.[56] The result of this pairing, describes journalist Alan Weisman, was the beginning of a verdant rainforest singing with life ". . . that had nearly

disappeared . . . Deer, anteaters, *chigüiros*, eagles, armadillos . . .,"[57] ". . . vermilion and yellow-breasted tyrant flycatchers, black-crested antshrikes, a blue-crowned mot-mot with a racquet-shaped tail, a rufous-tailed xenops, bananquits, brown-throated parakeets, a dusky-billed parrot, and a plump tinamou quail, swaying in the feathery *caño* treetops."[58]

When given a chance, natural cycles must have power in the most desolate places. For on his recent visit, writer Paul Kaihla observes, "Over three decades the evergreens spawned—without human intervention—an ecosystem that now boasts more than 200 plant and animal species."[59]

The Caribbean Pine reveals that the nurturing power of trees may also be a healing power for the earth herself, if we allow ourselves to learn from them. And the whole astonishing story of Gaviotas shows the need for a generalist's perspective to unify the often isolated findings of specialists, for learning and discovering in the context of integrated living systems. Not only does this approach take a holistic view of the earth and the energies pouring through her, it is also a cornerstone of the wisdom of ancient cultures—that the mysteries within and without us are inextricably linked.

Can we embrace our living planet this way and look at ourselves as part of it, not as a creature outside or superior to its natural rhythms? Isn't accomplishing this a matter of changing our own dreams and expectations for how we desire the world to evolve?

Perhaps these are questions Lugari pondered. He named his dream village for the yellow-billed terns (*Sterna superciliaris*) he saw when first visiting the area, known as river gulls, *gaviotas*.[60] His choice might have seemed fitting to poet Emily Dickinson (1830–1886), who tells us so reverently, "Hope is the thing with feathers . . ."

The smooth-skinned beech, needlessly beautiful even without her garments, appears a bit extravagant each spring.

She titters with twig and bud the way a great aunt changes pristine outfits daily, until she arrives at just the right shade of plum for a river promenade, the hue of lime in her plaited leaves or a coppery burnt maroon. ❧

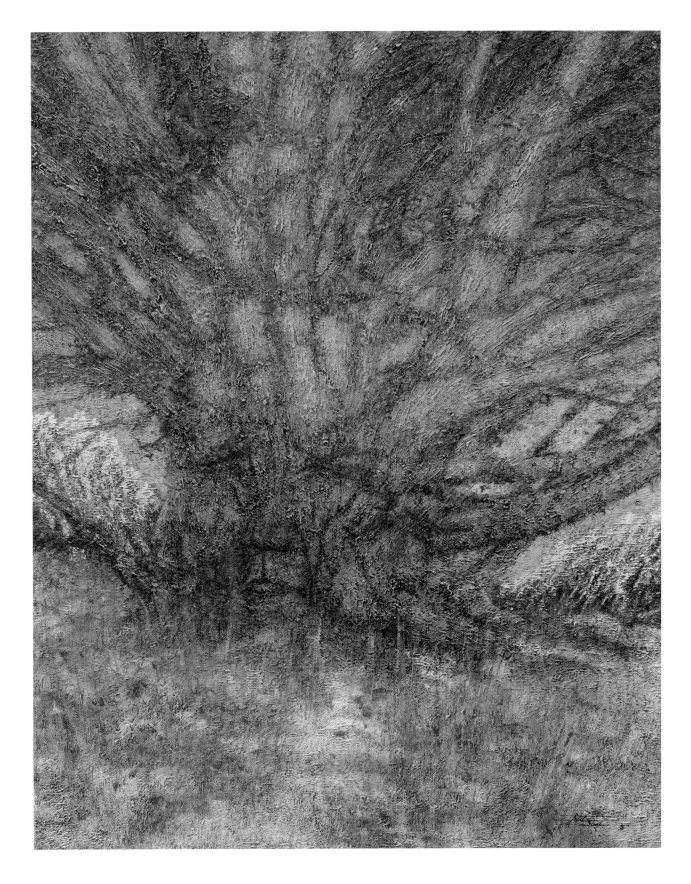

AMERICAN BEECH (*FAGUS GRANDIFOLIA*)

Ω

American Beech (*Fagus grandifolia*):

A robust genus that stands for prosperity (and an old friend, eighty feet tall with a girth of twenty feet, who has posed proudly for several portraits), her expressions are constantly changing. Rarely does she decline anyone the chance to take that first step, to swing from her smooth limbs and climb as high as our imagined summits to touch the clouds. Why should she care about us? Why should it matter? And why should we care about her, a threshold to the sky? In the words of the Lorax, seeking to save the Truffula Tree,

> *UNLESS someone like you*
> *cares a whole awful lot,*
> *nothing is going to get better.*
> *It's not.*[61]

The mountains in this painting represent abundance, as they do for various native cultures around the globe, from the Adirondacks to the Himalaya. Is there a message within the symbolism of mountains from which we can learn? "It may seem absurd to believe that a 'primitive' culture on the Tibetan Plateau could have anything to teach our industrial society," observes linguist and director of the Ladakh Project, Helena Norberg-Hodge. "Yet we need a baseline from which to better understand our own complex culture . . . Western culture depends on experts whose focus of attention grows more and more specialized and immediate at the expense of a broader, long-term perspective."[62]

"It was never previously possible to affect the climate, to poison the seas, or to eradicate forests, animal species, and cultures at the rate that we are doing today. The scale and the speed of our destructive power has never been so great."[63] ". . .We urgently need to steer toward a sustainable balance—a balance between urban and rural, male and female, culture and nature."[64]

She concludes that ". . . our search for a future that works is inevitably bringing us back to certain fundamental patterns that are in greater harmony with nature—including human nature."[65]

The idea of abundance, however, means more than plants to harvest, game to hunt, or water to drink. It refers to spiritual fullness (and our physical well-being and vitality that grows from this), the abundance of Spirit so well described by poet Anne Sexton as an endless well that nourishes us all:

Then the well spoke to me.

It said: Abundance is scooped from abundance

yet abundance remains.

Then I knew.[66]

Looking at the current state of the environments in which we live (the ground and water we have poisoned, the air we have clouded with fumes from our factories and vehicles), one might ask, just what is this fullness in lands whose resources have been plundered recklessly ever since Europeans arrived? . . . "The greatest fullness seems empty," says Lao Tzu, "And yet its use is endless."[67]

The idea of abundance . . . means more than plants to harvest, game to hunt, or water to drink.

It certainly can't have anything to do with material economics, because all of that is finite—as finite as the reluctance of our culture to change our dream of rampant consumption and simply say enough is enough. Although, when we look within, the whole premise of spiritual economics rests on the idea that there is a limitless spring of consciousness to draw from and sustain us.

All this is full. All that is full.

From fullness, fullness comes.

When fullness is taken from fullness,

Fullness still remains.

OM shanti shanti shanti

　　—Isha Upanishad, Opening invocation.[68]

The notion of mountains signifying abundance may explain why sacred mountains are as widespread as sacred trees, by which it is thought that humanity is capable of touching the realm of the divine. For the same reason, the mythological Cosmic Mountain, or "... the image of a 'Center of the World' and of the Cosmic Axis ...,"[69] is equated with the World Tree or Cosmic Tree.

"The tree," says Joseph Campbell about a Shinto myth of Japan, "is the World Axis in its wish-fulfilling, fruitful aspect ..."[70] Not surprisingly, Shinto means "the Way of the Gods."[71]

Mircea Eliade explains that this symbol of fertility and the constantly regenerating universe "... is related to the ideas of creation, fecundity, and initiation, and finally to the idea of absolute reality and immortality. Thus the World Tree becomes a Tree of Life and Immortality as well."[72]

The Journey

These trees carry the knowledge of their forebears.

Have you listened to them speak?

Have you ever tiptoed giddily between the sugar maples, scolded by chipmunks and feisty squirrels chattering like persnickety gnomes? ❧

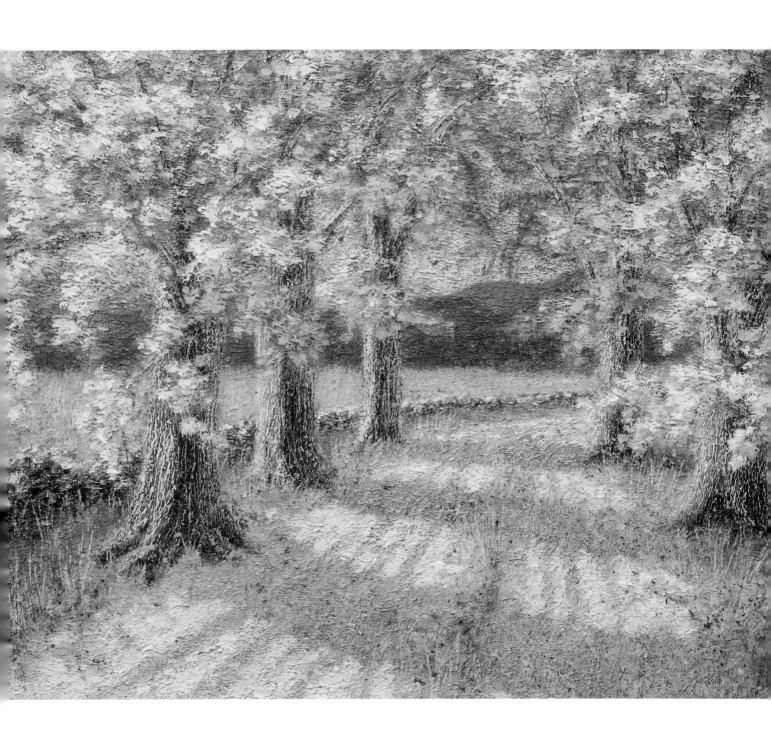

SUGAR MAPLE (*ACER SACCHARUM*)

☋

Sugar Maple (*Acer saccharum*): A swaiting dirt track through yellow and gold foliage that called to mind the Navajo Pollen Path chant as I painted:

Beauty before me

Beauty behind me

Beauty above me

Beauty below me

Beauty to the left of me

Beauty to the right of me

In Beauty I walk the pollen path[73]

The colors of pollen seemed to have settled over the universal hues of divinity in the species that also correspond to originality, determination, and a hunger for new experiences.[74] The apparent route here leads between five trees, a figure representing the cardinal directions—plus one. North, South, East, and West are indicated by four. Although in order to address one's self to the four horizons and sanctify every aspect

of the lands where one lives, one must stand at the center and be a part of that place. The fifth direction becomes the core of one's self, the divine centerpoint and *axis mundi*,[75] the mythological world axis.

In that same sense, five is equated with the pentagram, "a sign of the microcosmos"[76] because it is analogous with the human figure (the head and four limbs), as well as the hand, the five forms of matter, and the five senses. It is also allied with the Hierophant in the Tarot, the archetype for whom spiritual work is vital, whose initiative is to learn and teach ways to bring forth the sacred aspect of ourselves into the world.[77]

While standing by my easel at the side of the road, that symbol's importance became clear, for it denotes ". . . our capacity and need to learn how *to walk the mystical path with practical feet*."[78] The same sage advice is found in many parts of the world, such as in this gem from Pakistan: *Trust in Allah, but tie up your camel.*[79]

Above the dirt road appeared something else, too, a hummingbird hovering in the foliage, defined by the pale blue of the sky falling within a triangular vista over the distant hills. As in the painting of Red Maples, that triangular shape may suggest inner knowledge for indigenous peoples—or our need to develop it. It also signifies fire in other cultures, and ". . . the aspiration of all things towards the higher unity."[80] The smallest wings of the air and part of the indigenous myths and folklore in the Western Hemisphere (for the genus is not found east of the Atlantic Ocean), the hummingbird is also the only creature with the capacity for several forms of flight: forward, backward, and hovering nearly motionless, recalling an ancient metaphor of inner stillness, ". . . like the flame of a lamp in a windless place."[81]

So it makes sense that this bird represents soulful perception for some indigenous cultures of the Americas, a kind of divine trust that all experiences are part of a sacred journey as it seeks the nectar and pushes onward for thousands of miles during its annual migrations from the tropics to Canada.[82] Intriguingly, Mayan beliefs held that the hummingbird "...already belongs to the next cultural era, the fifth world."[83] This era, or *Pachacuti*, also referred to as "change of time,"[84] we are now said to be entering, with the chance to reawaken the harmony and balance of the earth sought by the hummingbird.

> Still, the question arises: where might this road lead you on your quest?

Other lore depicts the hummingbird as a powerful love charm, or a resourceful traveler with supernatural powers,[85] likely related to a common myth about its ability to cleverly hitch rides during migrations, snuggled into the feathers of larger birds such as eagles or geese.

In a fitting metaphor for our own lives, the maple leaves (that outline the blue hummingbird in the painting) turn gold and translucent as the sap retreats into the core of the trunk. Sap is *rasa* in Sanskrit, the essence "... which brought that entity into being ..."[86] But it doesn't cease to exist when the leaves drop to the ground. It simply awaits a new form to energize after the darkness of winter, conceivably the same essence that pushes us forward.

Still, the question arises: Where might this road lead you on your quest?

"Two roads diverged in a yellow wood ..." reflects Robert Frost (1874–1963) in his renowned *The Road Not Taken*, concluding, "... I took the one less traveled by, And that has made all the difference."

Whether the road one chooses means attempting to live as part of this earth, or changing the story one is already living by dreaming a new existence into being, that doesn't mean the journey will be easy. *Dreams are wiser than men*, says a proverb of the Omaha,[87] but changing our dream takes some focus on what we wish our dream to become. A scripture of India cautions famously, "Sharp like a razor's edge is the path, the sages say, difficult to traverse . . ."[88]

So how does one begin? You must ". . . ask yourself, and yourself alone, one question," instructs a shamanic Yaqui *brujo* from Sonora, Mexico. ". . . Does this path have a heart? If it does, the path is good; if it doesn't, it is of no use . . ."[89] One might then ask, what path are we on as a culture? Can we afford to continue treating the earth with such reckless abandon? Indeed, *Does this path have a heart?*

Have you stroked the rice-paper flesh of birch,

pale as a tart with her heavy mascara?

Her sassy wink, that audacious eyeliner of black ink, is moved by mystery

and desire. ঞ

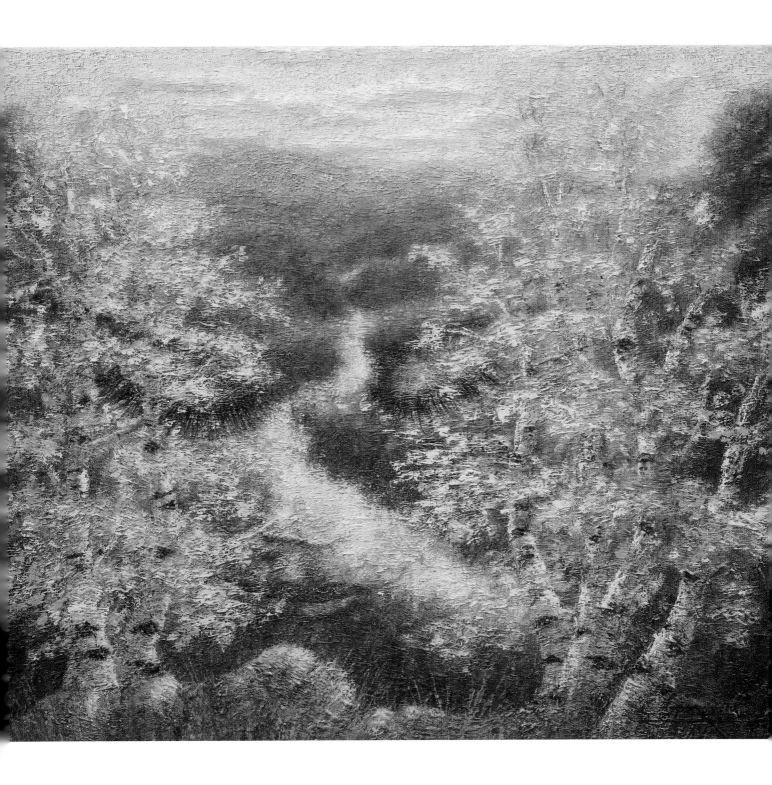

White Birch, Paper Birch (*Betula papyrifera*)

W hite Birch, Paper Birch

(*Betula papyrifera*): If we are to explore the question of whether this path has a heart, the fair birches on either side of the river vista offer a gateway through which we can embark. Beyond their decorative value in the West (in addition to the edible fruits and medicinal oils of some species[90]), these light-skinned trees are woven throughout shamanic rituals in Central and Northern Asia.[91] They are often equated with meekness.[92] But how meek or humble must we be? And how far do we need to go to find answers? In spite of the smothering or annihilation of countless earth goddess cultures, the knowledge still exists for how we might live in accord with the lands and waters that sustain us.

"The shining water that moves in the streams and rivers is not just water, but

the blood of our ancestors," explains legendary Suquamish Chief Seathl (Seattle) in his oft-quoted speech (delivered in 1854). ". . . Each ghostly reflection in the clear water of the lakes tells of events and memories in the life of my people. The water's murmur is the voice of my father's father. The rivers are our brothers . . ."[93]

What is so important about the wisdom of indigenous cultures? All over the earth can be found signs of ancient knowledge that offer an understanding of how to live *with* the earth. The Obiri paintings of Northern Australia, rendered exquisitely by the Gagadju and Kunwinjku peoples, predate the Egyptian pharaohs by 20,000 years. These reflect a knowledge in many areas far more sophisticated than that of occidental cultures, and a reverence for the land.[94]

And yet occidental cultures term this knowledge "uncivilized." Australian journalist John Pilger points out that the meaning of words depends on their historical context. "The verb 'to civilise,' when used of Aborigines, meant to domesticate—that is, to enslave. 'Dispersal' was a euphemism for mass extermination."[95]

So we must listen for the truths that uphold more ancient beliefs. "The land is *us*; it is our mother," a Walpiri man tells Pilger. "To know the land, to know and love where you come from, and never to go out and destroy it, is being right . . . is being civilised."[96]

Aboriginal author Hyllus Maris writes:

But how meek or humble must we be? And how far do we need to go to find answers? In spite of the smothering or annihilation of countless earth goddess cultures, the knowledge still exists for how we might live in accord with the lands and waters that sustain us.

I am a child of the dreamtime people,

Part of this land like the gnarled gum tree,

I am the river softly singing,

Chanting our Songs on the way to the sea . . .[97]

This so-called uncivilized knowledge is that of the sacred feminine, familiar to some as the "Spirit of the Fountain" or the "Mysterious Feminine."[98] (It is also represented in the frontispiece of this volume, *The Valley Spirit*,[99] inspired by a linden (*Tilia Americana*) growing in the region now known as western Massachusetts.)

The Kagaba of Brazil describe it beautifully:

The mother of our songs, the mother of all our seed, bore us in the beginning of things and so she is the mother of all types of men, the mother of all nations. She is the mother of the thunder, the mother of the streams, the mother of the trees and all things . . .[100]

It could be that the sacred feminine simply awaits our interest, like the contemplative visage that appears between the birches. Her lips border the lower curve of the river. On both sides of it her downcast eyes with long lashes emerge in the center of the painting.

It could be that the sacred feminine simply awaits our interest, like the contemplative visage that appears between the birches.

Moved by whose desire?

Who hears what we hear, and sees what we see?

Who is the sap of the sap in all green things that grow?

Who bends granite with rivers and splits seams in the trunk of a perched

ponderosa? ❧

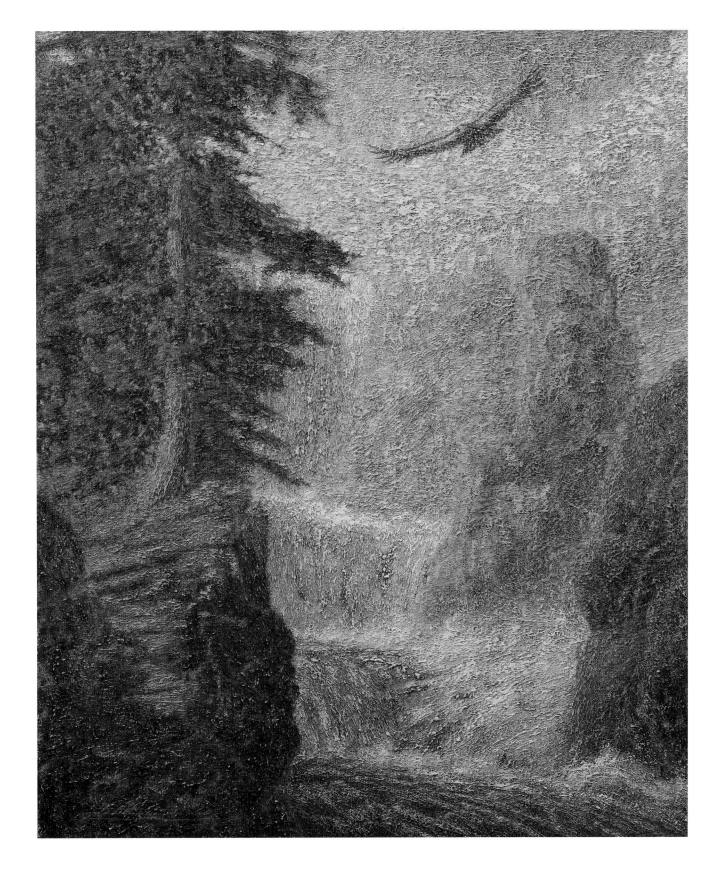

PONDEROSA PINE, YELLOW PINE (*PINUS PONDEROSA*)

�Ω

Ponderosa Pine, Yellow Pine (*Pinus ponderosa*):

Like the inquisitive rock profile in the lower left foreground, we might simply turn our attention to the wisdom of those creatures already pushed to the brink of existence. The California condor (*Gymnogyps californianus*) is one of them, the largest flying bird found on the continent referred to as Turtle Island by some native cultures, wings of the air that have been around since the time of the dinosaurs. Nearly exterminated by two-leggeds, its only hope may lie in an extensive breeding program and, at last, the good intentions of man.

Painted directly behind this great soaring scavenger, the gilded mountainous terrain becomes the head of a condor, its massive wings spreading out in the form of two craggy escarpments and its wingtip feathers mirrored in the lower limbs of the ponderosa. It is tied mythologically to various indigenous peoples, and crucially so

to the Chumash (of the southwestern region presently called Southern California); if the condor vanishes from the earth, the Chumash believe that they will too.[101]

The condor also appears with the eagle in various forms and legends around the world, where the eagle represents material and technological energies and the condor represents spiritual and compassionate energies, comparable to the energies of yin and yang. (On the continent called South America, the Andean condor, *Vultur gryphus,* plays this role.) In the late 1400s, it was known to many indigenous cultures that a period of imbalance and conflict was coming when the spirit of eagle would dominate the spirit of condor, and that the next period of five hundred years (the fourth *Pachacuti* or cultural era, also taken as a name for an Incan ruler, giving it the meaning "he who rules the world"[102]) would pass before an opportunity arose for these energies to regain balance.[103]

Now, five centuries after the arrival of Columbus, occidental cultures are seeing an awakening of compassionate interest for indigenous cultures and their wisdom. We are entering the fifth *Pachacuti*, a period when the eagle and the condor have an opportunity to soar the skies with equal power again, two aspects of what the shamanistic Laika of the Amazon and the Andes equate with the level of Spirit.[104]

Throughout hunting and planting mythologies, birds are considered to be spiritual messengers, integral beings in the realm of that primary element called air. They, or feathers, ". . . represent spiritual messages that have been cognized or brought into conscious awareness."[105] No wonder that numerous revelatory creatures are portrayed as wings of the air; the Siouan Thunderbird, the Chinese Dragon who rides on the clouds of storms and speaks with thunder, or the Hindu one-eyed

bird, Garuda. These are functionally related to "the Archangel Gabriel of Judaism or Christianity" and "the *Jibrail* of Islam."[106]

That is why feathers, either found on one's path or deliberately arranged, are perceived as symbolic of the divine. The explorers of alchemy, a medieval form of chemistry, related air and winged creatures with the mental fields of consciousness or the mind. They not only sought a means for transmuting base metals into gold, but a universal solvent and elixir of life; in cultures which embrace mysticism, that may be the stuff of consciousness itself.

DREAM TIME

How would we escape our mechanical heat without the hickory's fragrant shade?

By plunging through fields of fireweed?

Or diving between false lotus blossoms into reflections of locusts? ๕

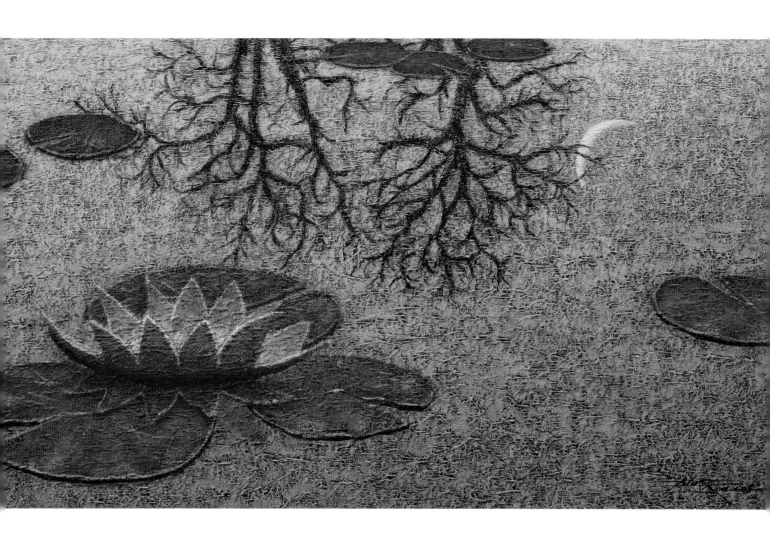

BLACK LOCUST (*ROBINIA PSEUDOACACIA*), WATER-LILY (*NYMPHAEA ODORATA*)

℺

Black Locust (*Robinia pseudoacacia*), Water-Lily (*Nymphaea odorata*): Despite its primeval winter silhouette, the locust has been associated with elegance. In this image, its reflected trunks create a downward triangle that hovers above a pond, a sanctuary where even the simplest form of a water lily can represent purity of heart among other aspects of the mystery. All of these objects abide in an illusory environment, a place where truths are difficult to recognize, one of "...an echo, a fairy city, a mirage, a reflection, an optical illusion, the moon in water ..."[107] The mirror, however, is also considered a conduit of clairvoyance and truth, present here in the guise of motionless water. It might take turning the world (or in this case, the book) upside down, but looking closer we open ourselves to the feminine gaze from the limbs of the trees.

Nine lily pads form a constellation around the blossom. While the figure has been chosen because of its meaning to this artist, in any belief system all numbers may be imbued with various symbolic values, each of them real enough for the believers. That is probably why, for example, so many traditions are thought to have given birth to the numbers, suits, and symbols that portray the archetypes of human experience in the Tarot. "Truth is one," says an ancient scripture, "though the wise call it by many names."[108]

Depicted with twelve petals around the center, a reference to the transcendent aspect of our existence, the lily represents beauty and perfection, fertility, and blooming spiritual enlightenment. Like the moon, it is a circle (a symbol of totality), a chakra in Hinduism, a mandala throughout the East, suggestive of the human psyche as well. A member of the genus *Nymphaea*, it abides at the meeting place of two elements, water and air. (As a common name, the lotus, a flower with endless implications, also refers to this family.) Across cultures, air is the realm of mental states of consciousness while water is the element of emotion, often represented as Scorpio, the astrological sign that experiences life at very deep levels. It is also tied directly to the moon, our feminine and magnetic nature.

Thus, blooming in the coarsest swamp or a shrinking pool, whether seen as the blue lotus of wisdom or the red lily of passion, the lily even becomes entwined with horizon phenomena, existing where water and sky meet. On an edgeless looking glass, it leads us within as it floats alongside the sun, moon, or stars, by giving new meaning to our relationship with the heavens and the mysterious aspect of our selves; and it speaks to us:

You are a child of the universe, no less than the trees & the stars . . .[109]

What would nurture that still small voice inside as well as a drooping bough that shields us from the rain?

Who lacquers every leaf in laughter, awash with birdsong, witty finches, warbler frolic, starling gossip, or a mourning dove's seductive coo?

What tunes our sanctuaries to the symphonies of blinking lightning bugs, the droning of crickets, the chanting of owls like sequestered monks? ❧

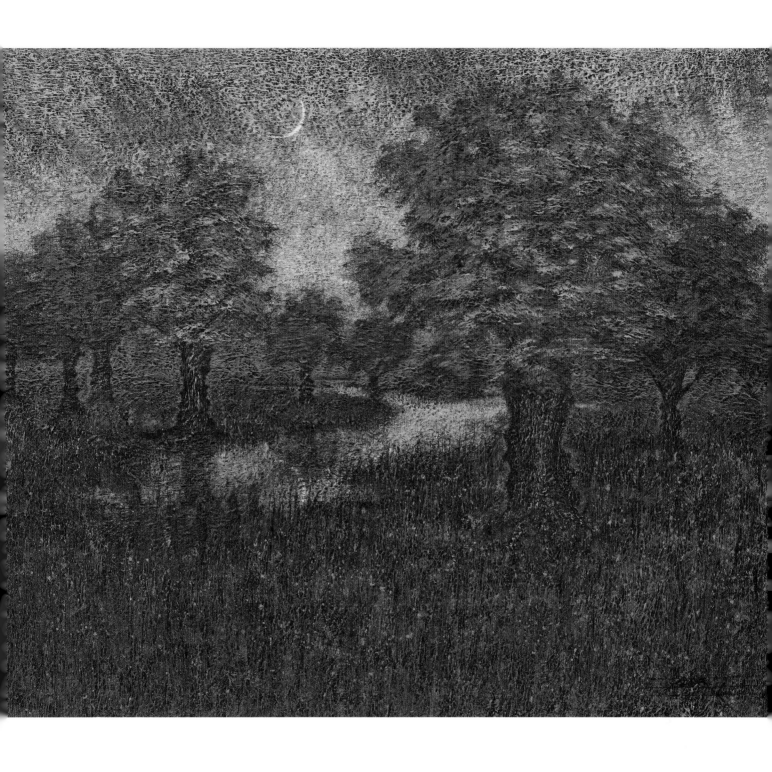

PECAN (*CARYA ILLINOINENSIS*)

P ecan (*Carya illinoinensis*): For past civilizations, groves were often venerated as dwelling places of the supernatural.[110] One still evening I set up my field easel on the flooded soil beneath these long-lived pecans, a nut bearer of the hickory group that was not domesticated until 1846.[111] As the moon descended, every aged trunk seemed to turn and listen in anticipation of the creature orchestra's opening nocturne—a confirmation, for me, of why native cultures think of trees as the Standing People.[112] They are also considered symbols of transformation in both East and West: the roots living with the ancestors, the trunk as the present, the branches reaching upward toward the future.

When we allow our imaginations to set these visions free, that is a first step in visualizing with the clarity of shamanic "seers," using what Australian indigenous cultures call "the strong eye."[113] Some of these peoples have a song that rejoices in the mysterious power of such things:

Tree . . .

he watching you.

You look at tree,

he listen to you.

He got no finger,

he can't speak.

But that leaf . . .

he pumping, growing,

growing in the night.

While you sleeping

you dream something.

Tree and grass same thing.

They grow with your body,

with your feeling.[114]

As I rendered nine great specimens in the soggy ground, the deep hooting of a horned owl (*Bubo virginianus*) stuck me profoundly, for the symbolism of these wings of the air varies greatly. (Partially obscured by foliage, one is perched here on the right side of the foremost pecan.)

In European cultures, the owl may be perceived as a creature who turns "away from spiritual light,"[115] while it is also thought to possess a "'demonic' gaze" in China,[116] and in Egypt it may signify "death, night, cold, and passivity" and the realm of the "dead sun."[117] Yet, for indigenous cultures of North America, with its ability to see and hear things that others cannot, the owl represents magic and wisdom. That

may be what we dearly need to reverse our destructive trends toward the natural world, wisdom as powerful as a tree that can transcend the illusions of boundaries across cultures and continents, from the Sioux:

Of all the many standing peoples, you O rustling cottonwood have

been chosen in a sacred manner . . . You will stand where the four sacred paths

cross- there you will be the center of the great Powers of the universe . . .

—Black Elk (1863–1950)[118]

to Islam:

Great tree of bliss! Your swaying braziers

Musk each second with Eternity!

I wade incessantly your sea of star-flowers

Your trunk soars blazing from my heart

—Jalâluddîn Rûmî (1207–1273)[119]

. . . for indigenous cultures of North America, with its ability to see and hear things that others cannot, the owl represents magic and wisdom. That may be what we dearly need to reverse our destructive trends toward the natural world, wisdom as powerful as a tree that can transcend the illusions of boundaries across cultures and continents . . .

Reclining in the cool shadows of sycamores, caressed by a June zephyr,

how can our delirious spirits resist running circles around the impatience

of a ticking drum? ∾

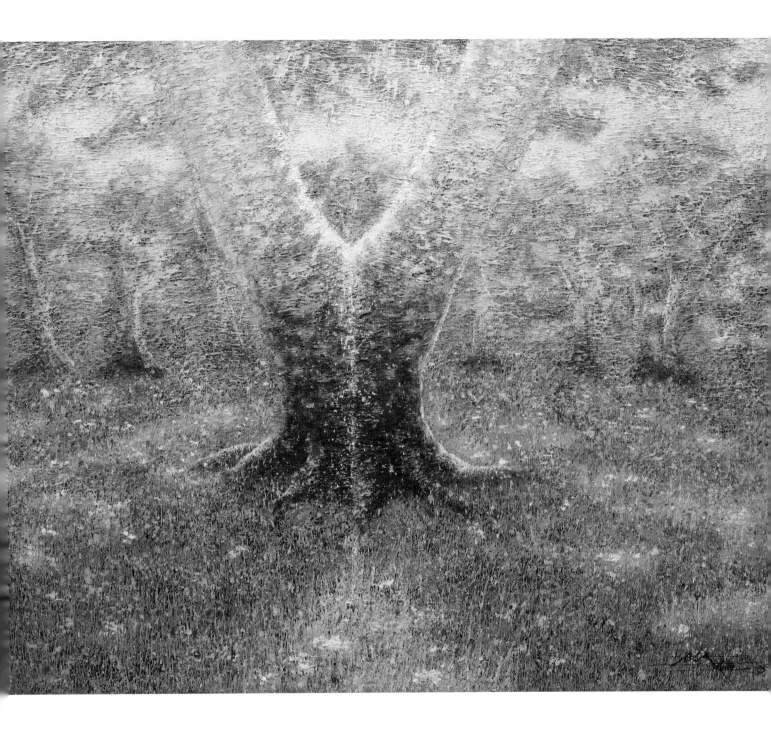

BUTTONWOOD, PLANE TREE, SYCAMORE (*PLATANUS OCCIDENTALIS*)

B

uttonwood, Plane Tree, Syc-amore (*Platanus occidentalis*): In painting the feminine curves of this sycamore, a species symbolic of curiosity, I noticed that its split trunk and shadow created downward and upward triangles, which can become the chalice and the blade, respectively, in Christian iconography, and are the essential components of the hexagram. (There are more notes on this symbol that correspond with plate 26: Black Spruce (*Picea mariana*). The chalice is equated with the Holy Grail in numerous legends, representing, for some, the feminine aspect of human experience, "…that which receives but also gives, a sort of spiritual womb for all who give themselves over to its mystery."[120] The blade is tied to the sword and Western masculine imagery, though it may refer to "mental clarity, inventiveness, and originality," be it masculine or feminine, symbolized by the Ace of Swords in the Tarot.[121]

These graphic opposites can be linked across cultures too. For certain indigenous cultures of the North American continent, the downward triangle may be seen as an upright **V**, representing creativity, ideas, or the creative power of the spirit. The upward triangle may then become an upside-down **V**, signifying the power of truth, or an individual "not easily fooled by half-truths or distracted by an eloquent tongue."[122]

But the split trunk and shadow also evolved before my eyes into an equal-sided cross, an icon that represents "paths crossing" for certain indigenous cultures of this continent. To the Sioux, "This form has much power in it, for whenever we return to the center, we know that it is as if we are returning to *Wakan-Tanka*, who is the center of everything; and although we may think that we are going away from Him, sooner or later we and all things must return to Him."[123] It can also be viewed as a double-sided **X** with one side facing East and one facing West. If we notice an upward and downward arrow pointing to the center of the trunk, it becomes a symbol of immortality.[124]

The pairs of contradictory energies found within us (as in the Tree of Knowledge of Good and Evil) are represented by the forked tree, especially for native peoples of the Plains.[125] Individuals or nations are capable of love and hate, two aspects that make up a whole; uncontrolled or not understood, they are powerful enough to tear us apart. If one half of the tree attempts to separate itself from the other, the tree will lose its sap, its life essence, and perish.

Of the eight trees in the background, the crown of the centermost combines with the sunlit bark in the fork of the ninth (the main subject in the foreground) to

create a symbol of the Great Seal, a hexagram. In numerology, nine denotes the circle, by the sum (three plus six plus zero) of three hundred sixty degrees, and by the four cardinal directions, four secondary directions, and center direction. With this allusion to the whole, it also refers to the human body (identified in Hinduism as the city of nine gates). In Bali, Indonesia, for example, the gods of the nine directions, *Nawa Sanga*, each dwell in a particular place in the body.[126]

Nine becomes the eight spokes (referring to the Noble Eightfold Path) plus the center in the Wheel of Dharma, a common symbol of Buddhism. It suggests another kind of circle, too, that of the calendar year (which in the age of the Sumerians was three hundred sixty days—also three plus six plus zero, adding up to nine—plus the five holy days that did not count in the realm of time[127]).

A sense of the temporal overlaying the timeless nudged me while I worked on this painting, and as the sun moved, the sycamore took on a ghostly pallor and the filtered light trickled swiftly down from the crook like sand through an hourglass.

Teachers

Yet how quick the season fidgets within the veins of tupelos, their foliage
turning—all too eager—like squirming crimson baitfish hooked on
brambly twigs.

The wind grows disturbed, fretful as a goshawk.

It whispers sorrowfully at first,

then builds until it is wailing through the pines. ❧

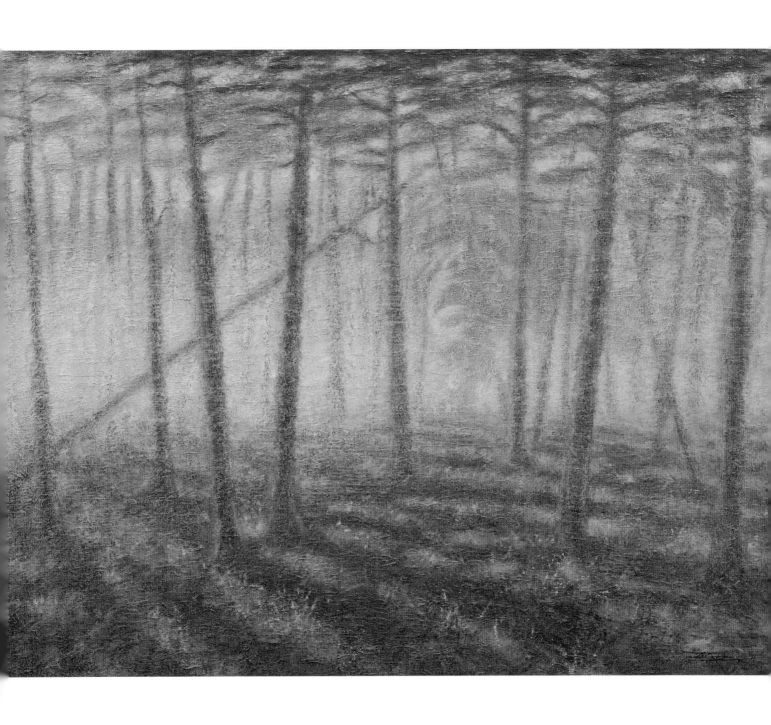

WHITE PINE (*PINUS STROBES*)

Ω

White Pine (*Pinus strobes*):Why is time so clearly running out? If we only look at trees as commodities (like this species associated with pity), that is no different from how we consider the rest of what we call "resources" on this planet: water, minerals, plants, and animals, even air. What could we gain by viewing them as our teachers?

Have we ignored our supposedly objective sciences, or refused to see the connection between the health of our inner and outer selves and that of the earth? Might we conclude that our current way of thinking has clearly failed? "Put plainly," says author Daniel Quinn, "in order to maintain the biomass that is tied up in the six billion of us, we have to gobble up 200 species a day—in addition to all the food we produce in the ordinary way . . . That kind of cataclysmic destruction *cannot* be sustained."[128]

In June of 1993, the President's Council on Sustainable Development determined, "More than 20 percent of U.S. cropland is seriously damaged from soil erosion. Underground water tables are dropping in many places. Less than half of America's original wetlands remain, and important U.S. fisheries have collapsed from overharvesting and habitat destruction. In the last two centuries, the country has lost 90 percent of its northwestern old-growth forests, 99 percent of its tallgrass prairie, and hundreds of documented species of native plants and animals alone."[129]

What have we accomplished since then? Our answer to our self-made cycle of crop loss has been to pump even more poisons into the soil that *we* are responsible for eroding into worthless dust; by the late 1990s that meant ". . . 2.2 billion pounds of pesticides annually," and ". . . 20 million tons of anhydrous ammonium fertilizer a year—as many as 160 pounds per person in this country alone."[130]

"Less than half of America's original wetlands remain, and important U.S. fisheries have collapsed from overharvesting and habitat destruction."

Referring to those natural habitats as "resources," and as "ours," we forget that there is nothing "ours" about the world in which we live; we have never possessed it. We are nature. It does not belong to us; it is not separate from us. So where is our compassion for all that upholds us? "As the world's largest economy, the United States is the world's largest single consumer of natural resources and the greatest producer of wastes of all kinds. These are not the conditions on which to build a durable future or to provide an example for the rest of the world."[131]

Have we done anything but squander those "resources" with our strip mines

and leveled forests, not just in North America, but around the world? Look at the forests we depend on. Jared Diamond reminds us that "we already know how to log them sustainably, and if we did so worldwide, we could extract enough timber to meet the world's wood and paper needs. Yet most forests are managed non-sustainably, with decreasing yields."[132]

> We are nature. It does not belong to us; it is not separate from us. So where is our compassion for all that upholds us?

Considering our consumptive habits, have we even tried to temper our thirst for various fuels? In the United States, opportunities were squandered for more than twenty years (since the 1980s) by not mandating improved fuel mileage for our vehicles.[133] Furthermore, as Diamond cogently points out, "Much American consumption is wasteful and contributes little or nothing to quality of life. For example, per capita oil consumption in Western Europe is about half of ours, yet Western Europe's standard of living is higher by any reasonable criterion, including life expectancy, health, infant mortality, access to medical care, financial security after retirement, vacation time, quality of public schools and support for the arts."[134]

So what is amiss with our perspective?

"Whether in remote subsistence economies or in the heart of the industrialized world, there is clearly something wrong with a system of national accounting that sees GNP as the prime indicator of social welfare," reasons Helena Norberg-Hodge. ". . . A nation's balance sheet looks better, for instance, if all its forests have just been cut to the ground, since felling trees makes money. And if crime is on the increase and people buy more stereos or video recorders to replace those stolen, if

we put the sick and elderly into costly care institutions, if we seek help for emotional and stress-related problems, if we buy bottled water because drinking water has become so polluted, all these contribute to the GNP and are measured as economic growth."[135]

With this mindset we refer to fish as "stocks" and to various animal, vegetable, or mineral harvests in terms of "futures." Ironically, we trade those "futures" as if they were infinite, representing whatever we take out of the earth (oil, gas, metals, etc.), green things that grow (soy, cotton, wheat, corn, etc.), and four-legged creatures we raise to feed us (hogs, cattle, etc.). The idea of trading futures is certainly a stinging metaphor. The system of capitalism is largely dependant on the idea of unlimited growth—but so is a pyramid scam. When one commodity is exhausted, we find another to take its place, develop the market, and consume—until that runs out. (A glance at the history of the fisheries gives plenty of examples of fleets ". . . committing ecological and economic suicide by depleting the oceans of bluefin tuna, shark, cod, haddock, sea bass, hake, red snapper, orange roughy, grouper, grenadier, sturgeon, rockfish, skate," and many other species.[136]) In the process, we have decimated the oceans, skies, and soils with a staggering list

> Considering our consumptive habits, have we even tried to temper our thirst for various fuels?

of environmental toxins. What were we thinking to pollute the very plants we eat with pesticides and ripening agents, fungicides and fumigants, while contaminating the animals on which we depend with hormones and pharmaceuticals? Did we believe in the science of our actions, or in the business?

Even "natural" disasters are used to fuel our appetites. "Most U.S. citizens

are not aware that national disasters are like wars: They are highly profitable for big business. A great deal of the money for rebuilding after disasters is earmarked for U.S. engineering firms and for multinational corporations that own hotel, restaurant, and retail chains, communications and transportation networks, banks, insurance companies, and other corporatocracy industries. Rather than helping subsistence farmers, fishermen, mom-and-pop restaurants, bed-and-breakfasts, and local entrepreneurs, 'disaster relief' programs provide one more vehicle for channeling money to the empire builders."[137]

Is it any wonder that people around the world suspect the motives of the United States and our confusing policies that seem willing to trade away our democratic ideals for the almighty dollar?

The United States accounts for only 5 percent of the world's population, yet consumes 26 percent of its energy.[138] According to the American Association for the Advancement of Science, by the beginning of this century, the United States was using the greatest share of twenty ". . . major traded commodities, . . . corn, coffee, copper, lead, zinc, tin, aluminum, rubber, oil seeds, oil and natural gas. For many more it is the largest per-capita consumer."[139] And that goes for the consumption of meat: "The average United States citizen consumes more than three times the global average of 37 kilos per person per year."[140] It also includes paper: "The average European uses 130 kilos of paper a year—the equivalent of two trees. The average American uses more than twice as much—a staggering 330 kilos a year. The paper and board industry is the United States' third largest source of pollution, while its products make up 38 percent of municipal waste."[141]

Yet there is nothing infinite about any temporal aspect of this earth, including the biomass that supports all of us. How many more life forms can we thieve from the bottom of the "pyramid" before the whole thing collapses? If we pay attention, we might hear the groaning of continents or, as in the great stand of pines depicted by this painting, the anguished cries of the wind.

Thankfully, this woodland is protected by a land trust now, amidst a surrounding rush of industrial and residential developments. But the responsibility for this protection doesn't just fall on the shoulders of nonprofit organizations. Large successful companies, such as Weyerhaeuser, appear to have focused on their values as well as on their stockholders, stating, "We agree with a vision emerging among governments and nongovernmental organizations that the best way to sustain forest resources globally is through a balance of three approaches:

- Protect one category of forests for biological diversity, recreation and other social and environmental values.

- Manage another category intensively to produce as much wood and fiber as possible while protecting the environment.

- Manage a third category less intensively to maintain more natural qualities, both to meet global needs for wood and to maintain local communities."[142]

If this vision is actually put into practice it may be an example of progressive corporate thinking, offering hope ". . . that men could be as effectual as God in

> How many more life forms can we thieve from the bottom of the "pyramid" before the whole thing collapses?

other realms than that of destruction."[143] In a capitalistic system, that could be vital to helping restore and sustain ecological balance. And balance is something the traditions of indigenous peoples have always understood.

We can learn from the Menominee people (of the region now known as northeastern Wisconsin) who have harvested timber since the 1850s, while preserving biodiversity and increasing the volume of standing board feet. Their well-documented cultural understanding of sustainable resource usage has succeeded despite competing in an economic system favoring unfair pricing for large corporations, many with slash and burn approaches that destroy ecological stability and prepare ravaged landscapes for monocultures.

"We name ourselves after the land we live with," explains Mashpee Wampanoag Ramona Peters. "Because, not only are we breathing in, we are also drinking from the water that is flavored by that very land. Whatever is deposited in the soil is in that water is in us. So we are all one thing, and we name ourselves after the place that is our nurturing. That sustains our life."[144]

This profound and simple understanding is reflected by native cultures around the world. In their thanksgiving ceremony, says environmentalist Thomas Berry, "The Iroquois remember and thank fifteen or more specialized powers, including the water, the rain, the wind, the earth, the trees. This is cosmological thinking. Such an experience evokes a sense of awe at the majesty of things. To participate in the sacred mystery in these moments is to know what it means to be human."[145]

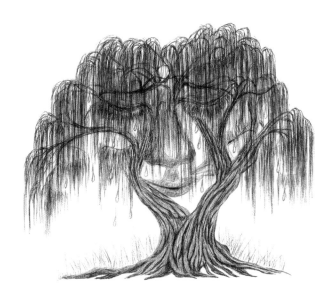

". . . the best way to sustain forest resources globally is through a balance of three approaches:

- *Protect one category of forests for biological diversity, recreation and other social and environmental values.*

- *Manage another category intensively to produce as much wood and fiber as possible while protecting the environment.*

- *Manage a third category less intensively to maintain more natural qualities, both to meet global needs for wood and to maintain local communities."*

It whistles coarsely in tatty brash cedars, arrogant sentries pushing the water's edge. ❧

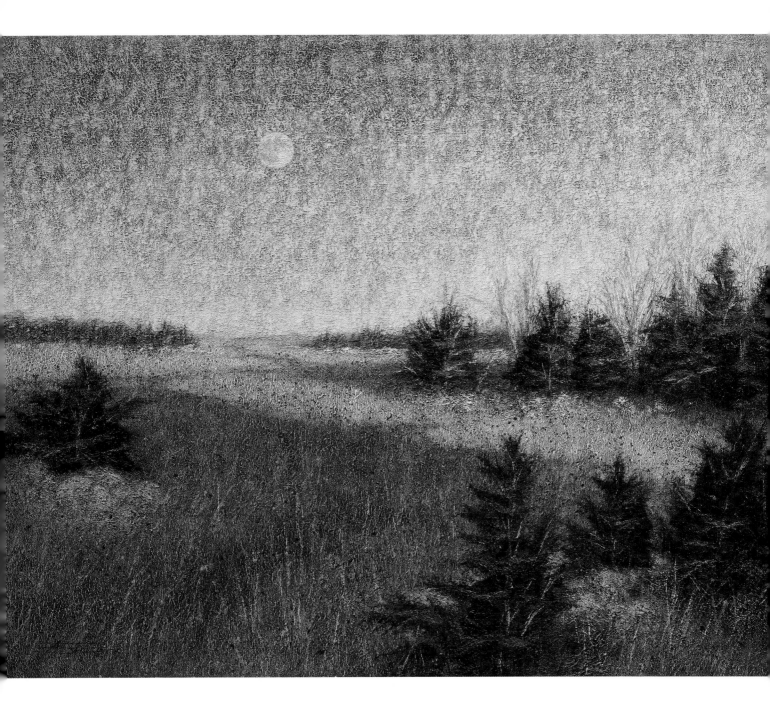

Atlas Cedar, Atlantic White Cedar (*Cedrus atlantica*),
Red Cedar (*Juniperus virginiana*)

ॐ

Atlas Cedar, Atlantic White

Cedar (*Cedrus atlantica*), Red Cedar (*Juniperus virginiana*): From the shadows, a path of sunlight takes us out to the horizon from where we might reach the full moon. As if hanging by a thread directly beneath it (to create a vertical axis of strength), a briny stream in this saltmeadow becomes a blue crescent moon. In numerous cultures, the crescent moon signifies the feminine principle and the world of changing phenomena. But when a star is added, as in Western heraldic emblems and coats of arms, it becomes a symbol of paradise.[146] The same ancient pagan image (referencing the worship of the masculine moon god of Arabian cultures) is found on flags of various Islamic nations such as Algeria, Pakistan, and Turkey.

The breeze in this canvas is cool, although—if you listen—the cedars make

caustic remarks in the gusts, scoffing, joking, cynically chattering—even being downright rude at times. Still, their expressions belie their incorruptibility, like the pure diamond-heart of the lotus that grows out of a dung heap on the side of a road. "The diamond, the hardest of known substances, cannot be crushed. Sand and stones can be ground to powder but diamonds remain unscathed."[147]

Is it really plausible to learn such things from trees?

Why not? By seeking out the symbols that live in the Standing People, we can tap into our creative selves and learn to see familiar things with fresh eyes. It means allowing ourselves to actually learn from trees or other living systems, to change our dream of how the world should be.

This implies changing the way we teach, too, because the status quo doesn't seem to be working. "If children are to learn how to think, design, create, and dream in systems, then they must be exposed to systems thinking at an early age."[148] That is the belief of Gunter Pauli, founder and director of the nonprofit organization Zero Emissions Research and Initiatives (ZERI), and author of the ZERI Fables that aim to help children and young adults ". . . develop their emotional intelligence, eco-literacy, and artistic/creative capacities."[149]

> This implies changing the way we teach, too, because the status quo doesn't seem to be working.

"In nature, everything has value," writes Pauli, "whatever is waste for a species of one kingdom, is a nutrient for a living organism in another kingdom . . ."[150]

While children learn science anchored by this broad perspective, ". . . they develop their emotional intelligence, which permits them to better understand

themselves, and to learn how to relate to others, as well as developing artistic expression as a communication system which goes beyond words for the first time, and finally there is the capacity to put all this together, to generate new ideas and concepts, interrelating the five intelligences into one context—our ecosystem."[151]

The "capacity to implement" lifts learning from the theoretical and puts it into the realm of action. One of many ways Pauli has been applying this principle is in the form of Marandua, an ambitious mega-eco-village in eastern Colombia modeled after Paolo Lugari's magical sanctuary, Gaviotas, and also referred to as Gaviotas II.[152]

So, take a second glance into the cedars' coarse limbs and short needles, their irreverent faces. Can you blame them for being icons of strength? Just look at ourselves. Are we strong enough to change how we view them, to see the saintly even in this raucous bunch?

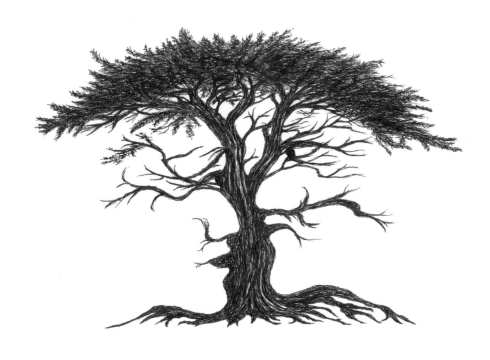

So, take a second glance into the cedars' coarse limbs

and short needles, their irreverent faces. Can you blame

them for being icons of strength? Just look at ourselves.

Are we strong enough to change how we view them, to

see the saintly even in this raucous bunch?

Can we afford to be so cavalier?

What of respect for the composure of elms, the vigor of ashes, the ruggedness of hawthorns? The same we should offer our elders?

Might we appreciate the pained spirits in the buckled knees of the cypress and the tenacity of pining islanders? Or is it that sultry outlook beneath their fronds to which we aspire? ໒

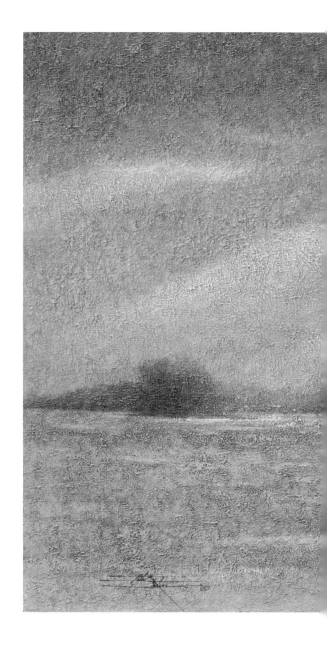

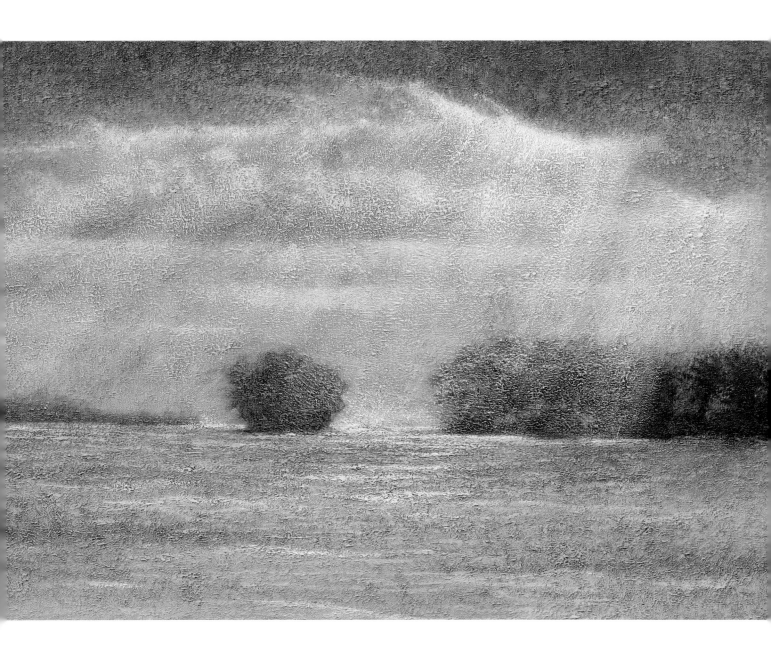

Bald Cypress (*Taxodium distichum*), Australian Pine (*Casuarina equisetifolia*), Coconut Palm (*Cocos nucifera*)

◎

B ald Cypress (*Taxodium dis-tichum*), Australian Pine (*Casuarina Australis*), Coconut Palm (*Cocos nucifera*): The reason we should consider trying to view things this way is simple. Just hold your breath for a minute to find the answer. And as you do, consider the cypress and the pine that steward these island environments, ciphers of mourning and sympathy for what we have done, while you bear in mind that the palm (in Christian traditions) represents victory over death.

In biological terms, we are inseparable from all green things that grow. We are inextricably linked like a singular organism through the carbon cycle, whose major features (photosynthesis, glycolysis, and respiration) use the same raw materials of carbon dioxide and water. "We know the sap which courses through the trees as we know the blood that courses through our veins," Chief Seathl (Seattle) says wisely.

"We are part of the earth and it is part of us . . ."[153]

Breath is both nonmaterial as well as substantial, the same that pervades this planet's atmosphere. It is rhythmic and cyclical, and considered by many cultures to be the bodily expression of universal energy (for example, *prana* in India, *qi* or *chi* in China) and the essence of the spirit—as well as life. In the region of what is now the southeastern United States, the principal deity of the Creek (an "English name for the political confederacy centered on the Muskogee and including the Hitchiti and others"[154)] was the god of the wind named Esaugetuh Emissee, meaning "'master of breath,' or 'he who carries life or breath for others.'"[155]

If we try looking at trees though our spiritual relationship with them, as well as our biological bond, we may have a chance to regard them differently. They might be mentors if we trust them. They live within us, no different than the moon, no different than the sea from which we evolved. They breathe with us, just as the tides of the oceans ebb and flow with the moon and the menstrual tides of the womb.

Do we notice the humility of willows?

(They don't always weep, you know. Sometimes they laugh clownishly, tickled as they wade among the loosestrife.) ❧

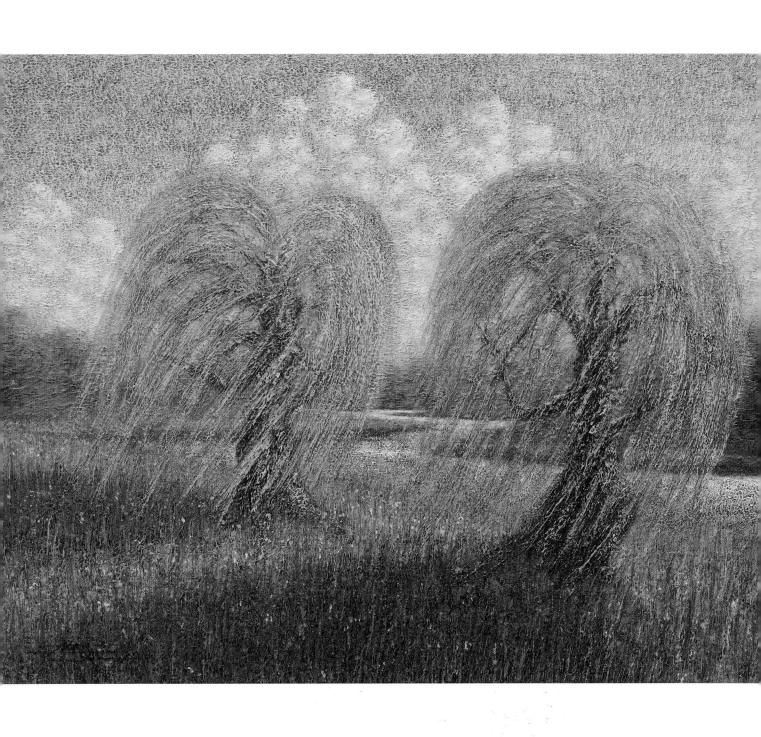

WEEPING WILLOW (*SALIX BABYLONICA*)

W eeping Willow (*Salix babylonica*): Linked with water and the moon, it is viewed as feminine and melancholy, an image of mourning. The act of resting beneath the flowing limbs is said to calm and heal the emotions. If so, imagine how that can heal one's physical being.

This clowning duo forms a circular image with the distant clouds that grow into a ghostly trunk and crown of foliage rising from the river between them. The combination becomes a green and fertile mandala, imparting the balance and overlapping symbols of yin and yang.

"It is relatively simple," writes naturalist Barry Lopez, "in a place where the river slows like this, fans out over the gravel, to examine aspects of its life, to come to some understanding of its history. See, for example, where this detritus has caught in the rocks? Raccoon whisker. Hemlock twig. Dead bumblebee. Deer-head orchid.

Maidenhair fern. These are dry willow leaves of some sort. There are so many willows, all of which can interbreed. Trying to hold each one to a name is like trying to give a name to each rill trickling over the bar here, and making it stick . . ."[156]

Willows are associated with courage, and have an erotic tenor (in Chinese traditions) as well as the power to protect one from enchantment or wickedness,[157] although I have questioned whether they can protect themselves from man's extravagances, having witnessed many crippled by acid runoff and contaminated effluents.

To me, that says a lot about how much we have degraded various ecosystems, because willows are notoriously hardy. They are among the foremost species (along with poplars, cottonwoods, and aspens) used in phytoremediative efforts to eliminate toxics such as heavy metals, polyaromatic hydrocarbons, and crude oil from water and soil.[158] Phytoremediation is actually ". . . a name for the expansion of an old process that occurs naturally in ecosystems as both inorganic and organic constituents cycle through plants. Plant physiology, agronomy, microbiology, hydrogeology, and engineering are combined to select the proper plant and conditions for a specific site."[159]

Once unified to gain a view of a whole ecosystem, these specialized sciences may offer us opportunities to learn from the phreatophyte trees that are capable of cleaning their own environments. Through the scientific method we can examine cellular differentiation in root, bark, leaf, and needle to understand what makes a tree work, what makes it struggle or thrive, survive or perish. But even in objective disciplines, we also have the power of imagination that can lead to greater comprehension and discovery, just as it enables us to explore mythology and symbolism for answers to what direction we should be taking.

By the same token, the potential applications of the sciences are worthless without our humane response to this earth and all her species, without our capacity for dreaming. That is to say, the healing power of trees like these phreatophytes can only come from their nurturing power—and our willingness to let ourselves be nurtured—just as our technologies need the context of our compassion to be of any lasting value. In the words of Paolo Lugari, "There's no such thing as sustainable technology or economic development without sustainable *human* development to match."[160]

Are we running out of time? I confess I have heard willows grieving more lately, perhaps for the *daily* loss of hundreds of species with every forest we ravage and every wetland we backfill with waste. We might consider weeping too, for with each species that we extinguish we are annihilating several hundred million years of evolutionary wisdom. When we do that, ". . . a life form ultimately tested since the birth of life disappears from the world beyond recall."[161]

Is this what we desire? It's not as though we have no knowledge of our commercial culture's environmental impacts, of the ways we indiscriminately consume resources whether they are renewable or not. What is our excuse? Lack of communal will?

It's enough to destroy various species for our material gain, laments Paul Hawken. "But how will we explain that the disappearance of songbirds, frogs, fireflies,

> Are we running out of time? I confess I have heard willows grieving more lately, perhaps for the *daily* loss of hundreds of species with every forest we ravage and every wetland we backfill with waste.

wildflowers, and the hundreds of thousands of other species that will become extinct in our lifetime had no justification other than ignorance and denial? How will we explain to our children that we knew they would be born with compromised immune systems, but we did nothing? When will the business world look honestly at itself and ask whether it isn't time to change?"[162]

Can the corporations driving our economic system learn anything from the symbolism of an endangered species?

An adage of the Nez Percé answers quite simply, *Every animal knows far more than you do.*[163]

Autumn

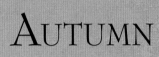

And what of the majestic innocence of oaks that carve the sky,

unknowing as a young girl awaiting womanhood? ❧

WHITE OAK (*QUERCUS ALBA*)

W hite Oak (*Quercus alba*): She warms herself in the autumn sunlight with the innocence of youth, while a sea of blue, of wisdom, creates a hazy horizon beyond her quiet sanctuary. Whether naked to the elements or clothed by gilded orange leaves, a color representing spontaneity and vitality,[164] the oak's hard strong wood has imbued her with the qualities of might and long life, even immortality.

> *. . .I am the size of the mighty oak tree,*
>
> *And I am the thoughts of all people*
>
> *Who praise my beauty and grace.*
>
> —Book of Camarthan[165]

Her leaves were thought able to hypnotize lions; her ashes were believed to protect crops from blight, her arrows "to keep snakes away from dunghills."[166]

Because of the ancient belief that the oak attracted lightning, it was connected with the god of the heavens, Jupiter or Zeus.[167] With that image of supremacy, oak leaves were used for military insignias in the U.S. Army, as well as in Hitler's Nazi Germany.[168]

The purpose of "seeing" or imagining the anthropomorphic trees in this book is not just to show the direct connection we two-leggeds share with the Standing People. It is to show what we can *learn* from them.

For example, the art of permaculture (permanent agriculture) takes its cues from nature, utilizing plants and trees that support each other and highlight their strengths, ". . . mirroring nature's most stable and productive communities . . ."[169] in the process. For many years, pioneering individuals have sought out nature's teachings: the ". . . forest-in-succession was the conceptual guide . . ." for the founders of the New Alchemy Institute on Cape Cod, John and Nancy Todd, who took some of their inspiration from Javanese farms in Indonesia;[170] the interactions of roots and leaves and canopies of different species also presented concepts about ecological succession to John J. Ewel, a botany professor at the University of Florida, whose teachers were the annuals, herbaceous perennials, trees, and vines of the Costa Rican jungle;[171] Australian ecologist Bill Mollison learned from Australia's forests;[172] and ethnobotanist Gary Paul Nabhan recorded the strategies of the Papago and Cocopa peoples of North America's Sonora, Chihuahua, and Mojave deserts.[173]

If we urge ourselves to be the best of students like these caring bioneers, natural systems offer their wisdom indiscriminately and by example, like the best of all teachers, to lead us away from our dependence on nonrenewable and destructive agricultural practices.

Fittingly, the oak may be a sign of the independence we must seek from petrochemicals and industrial farming. Chosen recently (in a nationwide vote hosted by the National Arbor Day Foundation) as the People's Choice for America's National Tree,[174] the oak has evolved over millions of years into almost as many varieties as there are nations of two-leggeds. But it has not thrived for this long on arrogance.

Haudenosaunee[175] Chief Oren Lyons puts it so eloquently (in his 1977 address to the United Nations): ". . . Economics and technology may assist you, but they will also destroy you if you do not use the principles of equality. Profit and loss will mean nothing to your future generations . . . I do not see a delegation for the four-footed. I see no seat for the eagles. We forget and we consider ourselves superior, but we are after all a mere part of Creation . . ."[176]

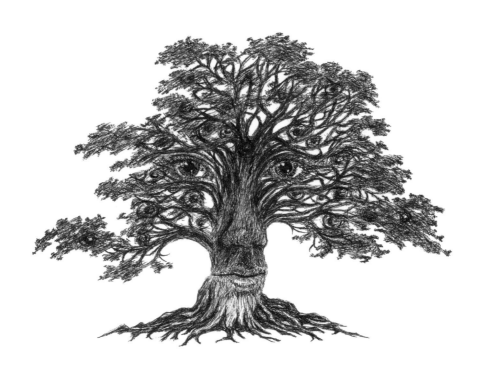

The purpose of "seeing" or imagining the anthropomorphic trees in this book is not just to show the direct connection we two-leggeds share with the Standing People. It is to show what we can learn from them.

Don't we realize the season led by bittersweet always seems so joyous,

even as it fades?

Is it some kind of ecstasy, encircled by fire, dancing like a dervish with

skull and moon? ❧

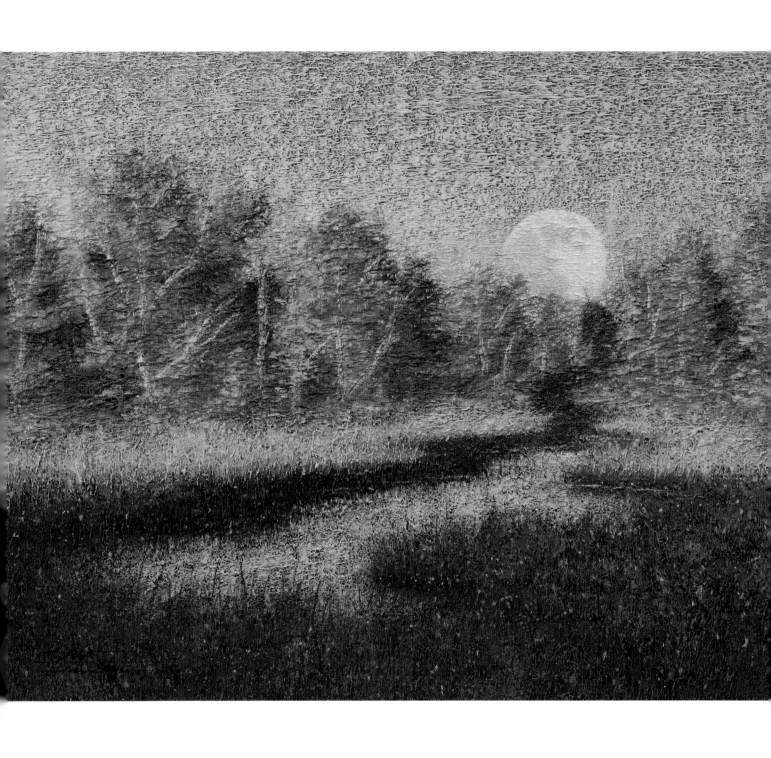

White Oak (*Quercus alba*), Red Oak (*Q. rubra*), Scrub Oak (*Q. ilicifolia*)

W

hite Oak (*Quercus alba*), Red Oak (*Q. rubra*), Scrub Oak (*Q. ilicifolia*): Just as the snake sheds its skin to be renewed, the moon slips free of its shadow. Through the process of rebirth, each becomes whole again. Thus, the serpentine water here, that element of emotion, shapeshifts as it wends its way to greet the rising face of the moon.

If the full moon is viewed as a symbol of humanity, reflecting the divine light of the sun,[177] it is also an inspiration for countless artists and composers, romantics and dreamers. For good reason too, because as Dr. Gustavo Yepes suggests, "In a dream you aren't limited by what is assumed to be permissible or possible."[178]

Equated with our magnetic and feminine aspects in occidental cultures, the moon represents the principle of the Goddess (or the yin energy) in the East. And because the powers of the moon are manifest in us, within the womb, it makes sense

that we should listen to her feminine wisdom too.

Oglala Sioux holy man Black Elk cautions us not to forget what matters:

> . . . the moon lives twenty-eight days, and this is our month; each of these days of the month represents something sacred to us: two of the days represent the Great Spirit; two are for Mother Earth; four are for the four winds; one is for the Spotted Eagle; one for the sun; and one for the moon; one is for the Morning Star; and four for the four ages; seven are for our seven great rites; one is for the buffalo; one for the fire; one for the water; one for the rock; and finally, one is for the two-legged people. If you add all these days up you will see that they come to twenty-eight. You should know also that the buffalo has twenty-eight ribs, and that in our war bonnets we usually use twenty-eight feathers. You see, there is a significance for everything, and these are things that are good for men to know, and to remember.[179]

The turpentine air grows
infused with humus, wild as
witchcraft casting lunatic spells
on butterscotch hickories and
sassafras of crème brulée.

And the oaks!
The inconceivable hues of the
oaks! Every different face and
creed, noble, bereft, red, white,
yellow, black, they huddle in
copses of glazed turmeric,
stands of powdered vermilion,
and groves of strawberry jam.

Each haunted by holiness like a
shaman's subterranean mantra,
breathlessly moving as rivers
move. ❧

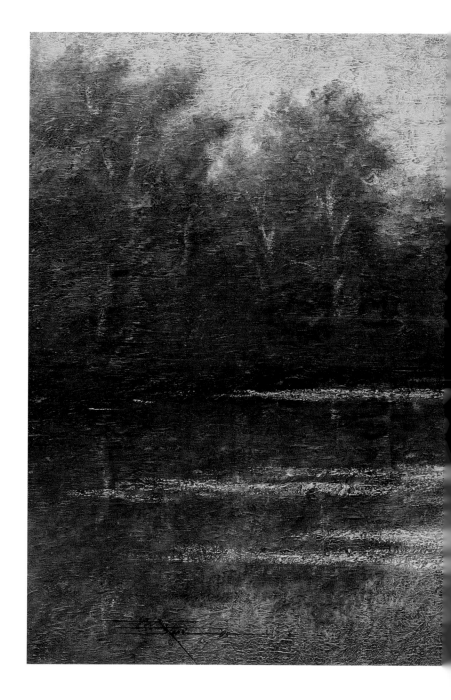

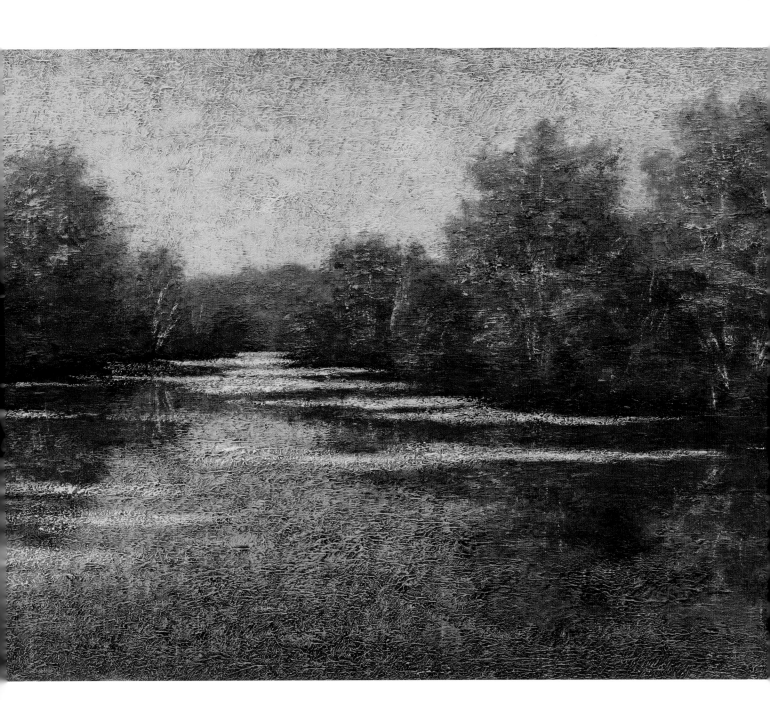

Shagbark Hickory (*Carya ovata*), Red Maple (*Acer rubrum*),

White Oak (*Quercus alba*), Scrub Oak (*Q. ilicifolia*)

S hagbark Hickory (*Carya ovata*), Red Maple (*Acer rubrum*), White Oak (*Quercus alba*), Scrub Oak (*Q. ilicifolia*): Here the river and sky, delineated by the horizon of trees, take on the shape of an hourglass again, with the seasons passing through like so many grains of sand.

As a reference to the sacred mother and her feminine energies that inform us, if you look carefully into the trees on the left side of the painting, one suggestion of her visage appears, hoping patiently for our compassionate attention.

In representing past and future, the river also shows us the need to look at the world from a spiritual perspective, not a political one. These inexorable currents beg us to see with the gaze of a soaring eagle, or from the angle of a camera that has been moved high above us to the heavens or the summit of a sacred mountain, like the Masonic symbol of the all-seeing eye hovering atop the pyramid on the one dollar

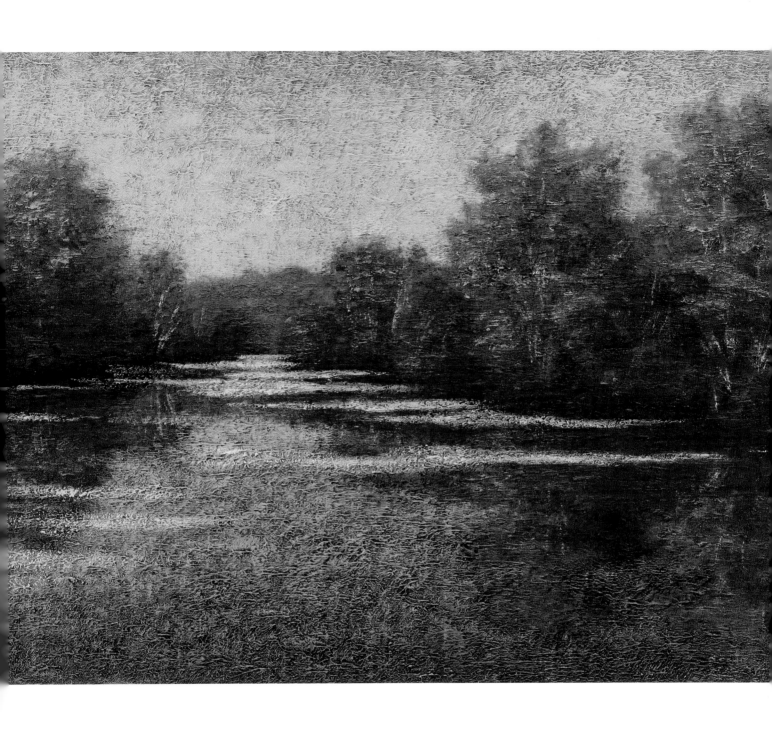

SHAGBARK HICKORY (*CARYA OVATA*), RED MAPLE (*ACER RUBRUM*),

WHITE OAK (*QUERCUS ALBA*), SCRUB OAK (*Q. ILICIFOLIA*)

Ω

Shagbark Hickory (*Carya ovata*), Red Maple (*Acer rubrum*), White Oak (*Quercus alba*), Scrub Oak (*Q. ilicifolia*): Here the river and sky, delineated by the horizon of trees, take on the shape of an hourglass again, with the seasons passing through like so many grains of sand.

As a reference to the sacred mother and her feminine energies that inform us, if you look carefully into the trees on the left side of the painting, one suggestion of her visage appears, hoping patiently for our compassionate attention.

In representing past and future, the river also shows us the need to look at the world from a spiritual perspective, not a political one. These inexorable currents beg us to see with the gaze of a soaring eagle, or from the angle of a camera that has been moved high above us to the heavens or the summit of a sacred mountain, like the Masonic symbol of the all-seeing eye hovering atop the pyramid on the one dollar

bill of the United States.[180] From that viewpoint, "Downstream, we can see war; but upstream, we can see the unrest among the people that will carry us to war, which is a much easier problem to address. Downstream is pollution; upstream is the question of why we're using plastic and throwing it on the ground."[181]

Cayuga Bear Clan Mother Carol Jacobs poignantly explains (in her presentation to the United Nations on July 18, 1995) that her people ". . . draw no line between what is political and what is spiritual."

"To us, it does not matter whether it can be scientifically proved that life as we know it is in danger. If the possibility exists, we must live every day as if it were true—for we cannot afford, any of us, to ignore that possibility. We must learn to live with that shadow, and always to strive toward the light. . .

> . . . *We are not a numerous people today. We believe that people who are close to the earth do not allow their numbers to become greater than the land can bear . . .*

> *And yet I tell you that we are a powerful people. We are the carriers of knowledge and ideas that the world needs today. We know how to live with this land: we have done so for thousands of years and have not suffered many of the changes of the Industrial Revolution, though we are being buffeted by the waves of its collapse.*[182]

Then chestnuts crackle, droop and snap, ghostly cottonwoods weep and crispen. Aspens molt their tempered longing. Walnuts pucker, parched and hapless. Ginkgos, sheathed in reptilian armor, bleach to quaking papyrus before unleashing a flurry of miniature fans.

Crabapples drop with soft cushioned thuds into overgrown grasses, between searching caterpillars anxious for a branch on which to spin dreams. "I am!" they cry out—big as a universe, their vanity—of beauty in another life yet the same as this.

Just as the light dances across the boughs of grimacing spruces, or the crippled stumps of their burial grounds. ❧

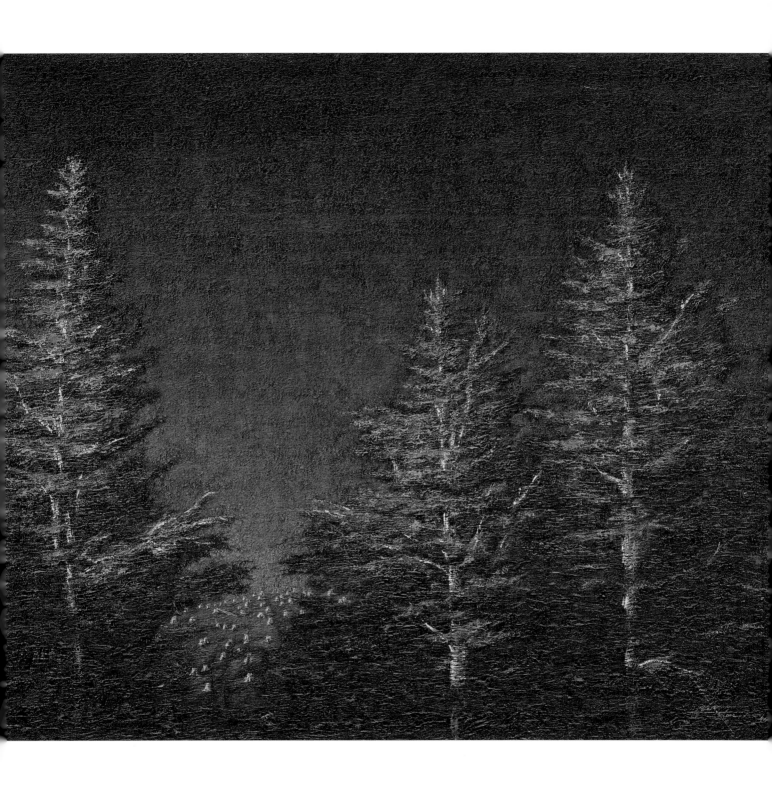

NORWAY SPRUCE (*PICEA ABIES*)

N

orway Spruce (*Picea abies*):

Is it feasible for Western cultures to adopt "sustainable" lifestyles and learn how to "live with" the land? (For that matter, is the meaning of the term "sustainable" at risk of losing its conceptual importance, becoming washed out in our popular culture?) Are we capable of preventing our numbers from becoming, in the words of Cayuga Bear Clan Mother Carol Jacobs, "greater than the land can bear"? Can recycling and reforestation programs alone have an impact? Or is there another way to tackle the dilemmas we face?

To begin the process of learning how to "live with" the land, one approach might be that of sanctifying the local landscape. Look again at the stumps on the far hillside. See if they take on the shape of grave markers. The opening in the spruces through which we view them becomes a hawk-nosed human profile. How can one

find an image of ruin and avarice in a stand of these regal trees? Only if man has been there.

Fortunately, the spruce's characteristics represent hope in many traditions, despite adversity. And the backdrop of the "purple" sky (built of greens, blues, and reds) is the color equated with royalty, as well as with "owning one's personal power."[183] We may need these qualities more than we know.

Since the beginning of his administration, President George W. Bush has sought to open the Arctic Refuge, forests such as the Tongass, and our national parks to be used for profit by oil, gas, coal, and timber companies. If forest industry policy is to "manage" forests by ". . . harvesting trees, reseeding and caring for the forest environment . . .," and if ". . . our forest population has stabilized,"[184] then, shouldn't we give our forest industry credit for reversing the destructive trends of the nineteenth and early twentieth centuries? Is it necessary to leave our mark on pristine environments like the Tongass?

Some people view the widespread clear-cutting of old-growth forest as a right or a way to earn a living, with no concerns for the impact of devastated watersheds and wildlife habitats. "This is a damn rain forest," says one logger, having been put out of work by the closing of the heavily polluting Ketchikan mill in 1997. "It was put here to log."[185]

Does that mean we should look more closely at the human costs of preserving a National Park? "'Save the animals, keep the people away' is a strategy that won't work and shouldn't," says essayist David Quammen. "Human pressures and needs will inevitably prevail . . ."[186]

If so, do we have a need to relate in a different way to these environments?

As documented by the Natural Resources Defense Council (NRDC), the actions of the forty-third president of the United States have threatened "to do more damage to our environmental protections than any other in U. S. history."[187]

In January 2005, NRDC Trustee Robert Redford sent a letter by e-mail urging the mobilization of millions of Americans and putting forth the position of the NRDC. He warned that congressional leaders were "pushing for a quick vote that would turn America's greatest sanctuary for Arctic wildlife into a vast, polluted oil field. Even worse, they [were] planning to avoid public debate on this devastating measure by hiding it in a must-pass budget bill." All the while they and the president knew ". . . full well that oil drilled in the Arctic Refuge would take ten years to get to market and would never equal more than a paltry one or two percent of our nation's daily consumption. Simply put, sacrificing the crown jewel of our wildlife heritage would do nothing to reduce gas prices or break our addiction to Persian Gulf oil . . ."[188]

...the spruce's characteristics represent hope in many traditions, despite adversity.

In the spring of 2007, the NRDC reported the Bush Administration's revival of a ". . . plan to sell off hundreds of thousands of acres of our national forests and public wildlands to cover budgetary shortfalls . . . The first of two proposals calls for selling off more than 270,000 acres of national forest lands spanning 35 states in a shortsighted approach to funding a rural schools program . . . The administration's latest scheme would give it the authority to sell upwards of a million acres or more of public wildlands—overseen by the Bureau of Land Management—anywhere in the

country and to use the majority of the proceeds for deficit reduction."[189]

Did any politicians and their supporters ask why those lands were sanctified to begin with, not only by First Nations since the dawn of history, but by our very culture that overtook these lands? Did they question the reasons for which Theodore Roosevelt created so many game preserves and bird reservations, national parks and monuments, and 150 national forests?[190]

David Quammen points out that ". . . national parks exist in the dimension of economics as well as geography, biology, and symbolism. To those, add two more. They exist also in the dimensions of politics and time. What has been done, however noble and farsighted, can be undone."[191]

As for the economic dimension, we can easily examine a national park or protected open space in terms of economic value; the analytical literature that examines the "valuation of natural resource preservation and open space benefits"[192] is extensive and conclusive. Trading that away for other shorter-term social or individual rewards is precisely what has created "an environmental deficit"[193] across this planet. Study after study cogently shows that if we are inclined to break down meadow and wetland, tundra and bog, or cliff and shore into graphic representations of dollar potential for development, mining, drilling, or logging, then we must ask: Is there any economic value to land that remains unscarred—as open space?

In the dimension of the symbolic, should we also ask: What is the same land's spiritual value?

Why? Because even in Western value systems, sustainable economic benefits grow out of the spiritual aspect of landscape; i.e., the economic value of open space is

inseparable from the spiritual value of open space. For example, a protected woodland adds dollar value (tax benefits, savings in municipal costs, etc.) to contiguous parcels of land by virtue of the fact it cannot be harvested or built upon. (This is to say nothing of the long-term economic benefits derived from spiritual health having a positive effect on physical health.) We can gaze through the foliage, or inhale the sweet fragrance of conifers. We can be stopped in our tracks by a view that takes our breath away, a simple act of participation in divinity. But this woodland's value is derived first from our connection with it that has no immediate economic or *practical* use. Thus, if there is value for our existence, and if half of our existence is spiritual, then one aspect of that value is also spiritual. And since no dollar worth can sustain the spirit, we need to ask what other kind of worth can be recognized in the land that sustains us? It's a pretty direct question that has been put to us through the ages: *Who gives you sustenance from the heaven and the earth?*[194]

> . . . since no dollar worth can sustain the spirit, we need to ask what other kind of worth can be recognized in the land that sustains us?

One could also challenge those same politicians and their supporters this way: When you find yourself on the threshold of departing this world, would you rather count your coins like Ebenezer Scrooge? Or walk through a ruined landscape, smeared by spills, razed to a treeless corpse, scarred by waste and permanent tire tracks and hulking steel carcasses of oil wells that will outlast a thousand summers?

Or would you not beg to lay down in a meadow beneath clear sapphire skies, to hear the cry of the hawk and the buzzing bees, to smell the clover and spruce, to feel

the earth's numinous rhythms throbbing up through your frail surrendering body?

"*Toitu he kainga, whatu ngarongaro he tangata . . .,*" says a Maori proverb, "the land still remains when the people have disappeared."[195] By that time though, what will we have done to the land? A Cree prophecy bluntly gives us an answer:

When all the trees have been cut down,

when all the animals have been hunted,

when all the waters are polluted,

when all the air is unsafe to breathe,

only then will you discover you cannot eat money.[196]

DARKNESS

Still, dying autumn plunges on as groaning limbs arc and whip, scattering leaves with the rush of breaking waves. Acorns loose themselves and plummet unaware, clattering down to bounce on rock and hardened ground; broken gradually by rain; speared by fangs of cold and ice; swept with winds; crushed by snows to freeze and thaw and freeze again.

And within, their seed.

Buried by soil, leaf, moss, peat.

Split by minutes.

Yes, and within?

Nothing.

Their seed perishes.

And then what, nothing? ॐ

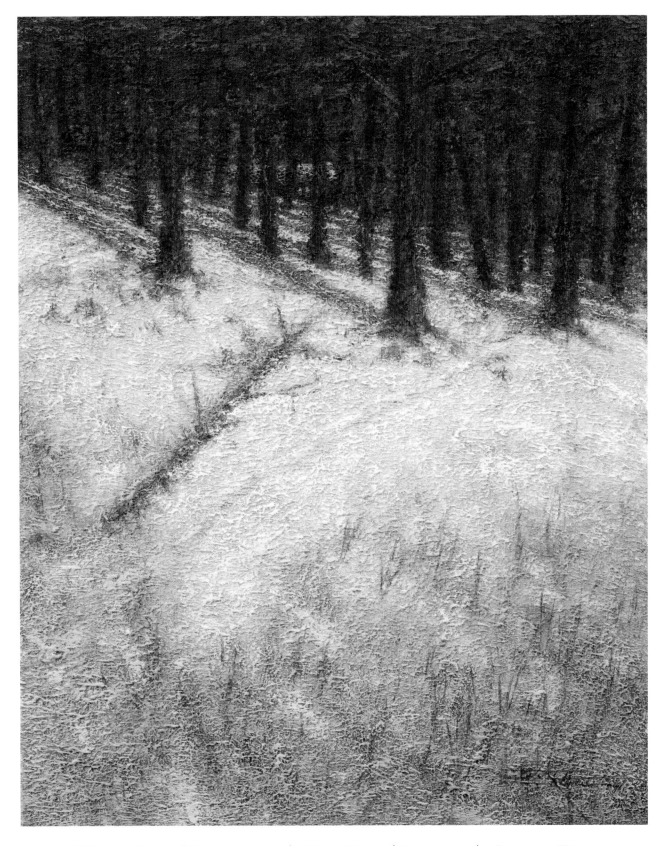

WHITE PINE (*PINUS STROBES*), RED PINE (*P. RESINOSA*), SCOTCH PINE, SCOTS PINE (*P. SYLVESTRIS*)

W hite Pine (*Pinus strobes*), Red Pine (*P. resinosa*), Scotch Pine, Scots Pine (*P. sylvestris*): Pines of pity, pines of philosophy—trees as representations of attributes perceived by man. Even the common Scotch pine, of little significance in European lore, becomes the Tree of Life in East Asia. Ever green and durable, with paired needles that are not split and lost to winter, it is an image of vitality, prolonged life, and a blissful marriage.

Here, passing in and out of shimmering moonlight, nameless footprints leave a wintry track. The very act of nocturnal painting amidst these pines left me ecstatic and breathless, with a sentiment expressed so well by Jean-Francois Millet: "Oh, how I wish I could make those who see my work feel the splendors of the night! One ought to be able to make people hear the songs, the silences and murmurings of the air. They should feel the infinite . . ."[197]

Do we need to look deeper to feel what he wishes for us? Tucked away in the farthest shadows is a warm cabin with a log fire burning, but to reach it we must make our way through the cold dark woods; a metaphor for where we are now.

We have reached the point, says Alberto Villoldo, where we must ". . . give up the ways of the conquistador and discard the masculine theology that values command, control, and dominion over nature, a theology that justifies the exploitation of the earth's resources for human consumption. Instead, we'll embrace an older mythology that has become lost to most humans, a feminine theology of cooperation and sustainability."[198]

As forlorn naked saplings pop, their blood retreats with ours.

While, even captive and dwarfed in our frozen gardens, the poplars stand proud and frail, guarding the next journey of our choosing. ❧

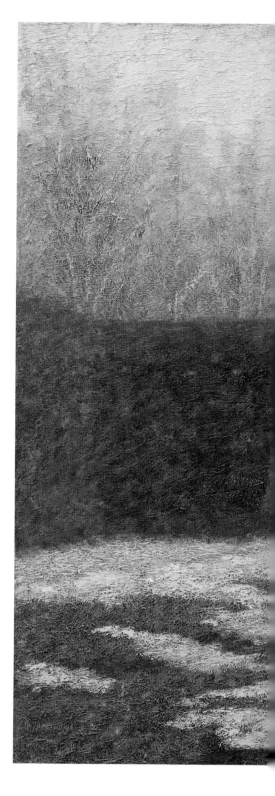

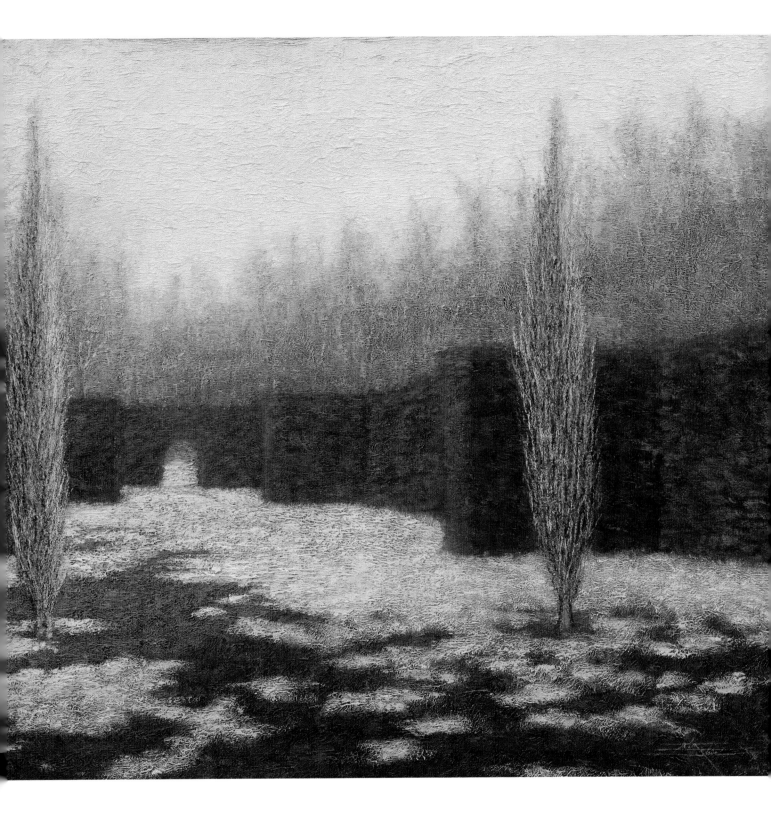

WHITE POPLAR (*POPULUS ALBA*)

ꙮ

White Poplar (*Populus alba*): How *do* we sanctify the lands that provide for us? The process of sanctification can be broken down into three basic stages: contemplation, consecration, and restoration. With their reference to the temporal, the poplars remind us that we must embark on this process now, following the wintry path between the hedges to the woods beyond. Their common name refers to "white," as does the path leading through snow, a symbol of sanctity and purity, because white is "the colour of maximum light . . ."[199]

The first step is to reflect upon the earth. "The earth is the mother of all people . . ." says Nez Percé Chief Joseph [Hinmaton Yalatkit] (1830–1904).[200] By considering, cherishing, or celebrating whence we have come, we can revere her as our own mother. In doing so, we identify the part of ourselves that abides in the

landscape. It is an act of participation with the enduring nature of our existence, with divinity. To accomplish this allows the opening of one's heart.

The second is to sanctify, to make every aspect of the environment symbolic of the Absolute, the Imperishable, Ultimate Reality, *Kiehtan* (Wampanoag), the Creator, the Great Mystery, *Wakan-Tanka* (Sioux), the Great Spirit, the One, *Tchementu* (Naskapi), the Highest Being, God, Allah, *Tirawa* (Pawnee), the One Above, *Io* (Maori), the Supreme Being, Buddha, Christ, Brahman—whatever name you wish to apply, whatever your belief system.

Sanctity is holiness, or a sacred thing. Mythologist Joseph Campbell refers to it as the "metaphoric relevance" of an object or space.[201] For example, look at a single drop of sea water; the essence of all the oceans is contained within it. By asking ourselves, "Of what is this symbolic?" we have opened a window into the mystery. And by viewing everything with reverence, each star, cloud, stream, rock, or tree, we consecrate the whole world. All becomes mythologized. It is a transforming experience. This is how earth goddess cultures look at the entire landscape—the lands and waters we live *with*.

The third step is to view the earth as a temporary gift that does not belong to us but for which we are responsible as custodians, and one we are returning or restoring to the children of our children. Even amidst lands that have been forsaken, there are mechanisms (such as land trusts, conservation restrictions, enforcement of existing protection for parks, forests, and historic sites) by which we can put this view into action. We can also uphold our humane response to these lands and apply our sciences for their recovery, a process that should have been exemplified by

the Environmental Protection Agency's murky designations of every Superfund site, "... an uncontrolled or abandoned place where hazardous waste is located, possibly affecting local ecosystems or people."[202] By many accounts, however, the Superfund program has been a failure.[203] How could it not be, with the EPA's own definition of a site stating that hazardous waste can only "possibly" affect local ecosystems? Do we need to redefine our views of these forsaken lands?

So says a timeless proverb of this continent's indigenous cultures: *Treat the earth well: it was not given to you by your parents; it was loaned to you by your children. We do not inherit the Earth from our Ancestors; we borrow it from our Children.*[204]

This may seem a daunting challenge, but as Lao Tzu writes notably, "A journey of a thousand leagues starts from where your feet stand."[205]

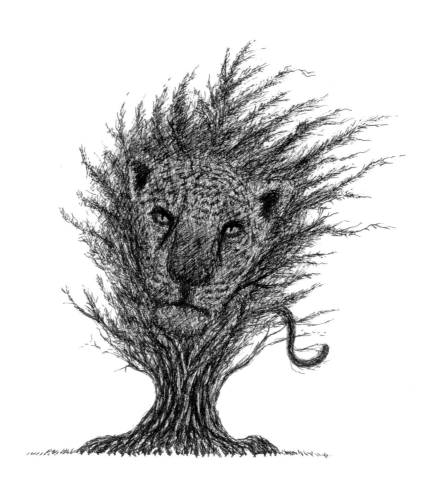

And by viewing everything with reverence, each star, cloud, stream, rock, or tree, we consecrate the whole world. All becomes mythologized. It is a transforming experience.

Can we bear the torment of grieving mulberries and whimpering alders?

Do we pity the shivering figures of mourning willows by the dead of charcoal winter skeletons?

Can we remain grateful to the embittered sassafras offering tea, the workhorse maples their bleeding syrup, the mistrustful lindens their root and bark? ❧

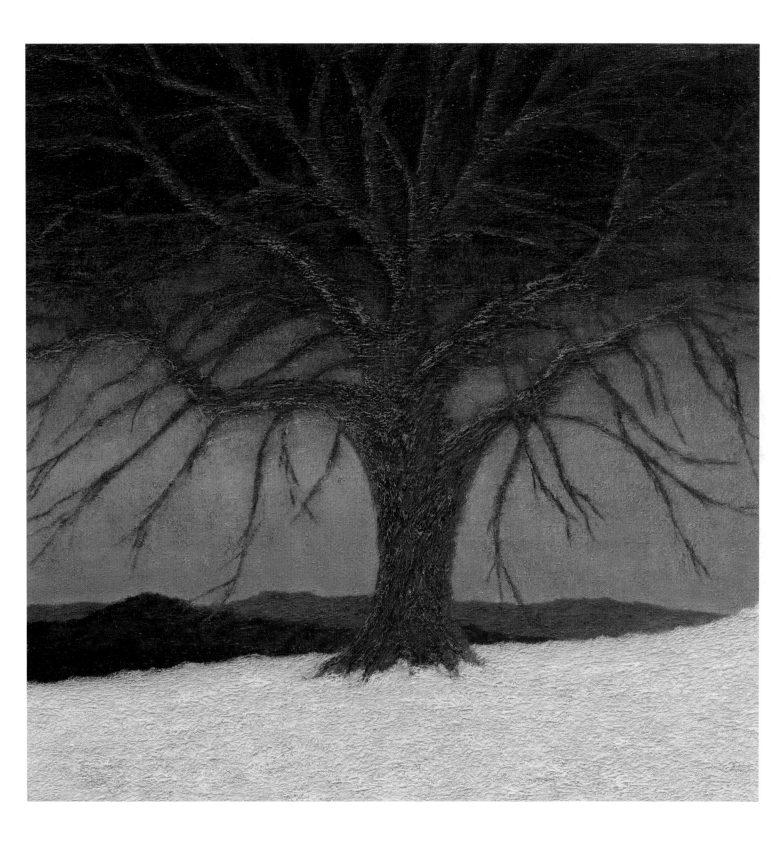

AMERICAN LINDEN, BASSWOOD, LIME (*TILIA AMERICANA*)

※

American Linden, Basswood,

Lime (*Tilia americana*): As I stood painting on an open ridge with the setting sun behind me, this proud linden took on an angry red hue. That may seem ironic, because in some cultures *Tilia* is an emblem of "fragility."[206] But it persevered as solitary as an axis of the earth (like the *axis mundi*, the world mountain or world tree around which everything revolves), and its expression seemed to darken, from wariness to resentment.

Hold on to what you believe, says a prayer of the Pueblo, *Even if it's a tree that stands by itself.*[207]

For what reason had the surrounding woods recently been stripped away?

A strip mall.

With such a biting metaphor in mind, I couldn't help wondering if this

specimen's solitude was a result of a short-sightedness or simply a want for cash.

The scene brought to mind Jean Giono's shepherd who planted one hundred acorns a day in a bleak landscape deforested by men. ". . . It was his opinion that this land was dying for want of trees."[208] Nobel Peace Prize winner Wangari Maathai may have felt the same about Kenya when she began planting trees and founded the Green Belt Movement in the 1970s.[209]

Or was the coming strip mall a disturbing symptom of something else?

"Stop being so greedy, and so selfish," warns a Javanese university student. "Realize that there is more to the world than your big houses and fancy stores. People are starving and you worry about oil for your cars. Babies are dying of thirst and you search the fashion pages for the latest styles. Nations like ours are drowning in poverty, but your people don't even hear our cries for help. You shut your ears to the voices of those who try to tell you these things. You label them radicals or Communists. You must open your hearts to the poor and downtrodden, instead of driving them further into poverty and servitude. There's not much time left. If you don't change, you're doomed."[210]

An Amazonian Huaorani Indian leader, Moi, puts it quite succinctly, after traveling to Washington, D.C. to stand up against drilling for oil in his homeland. Having never before experienced televised baseball, hot showers, and *The Washington Post*, he concludes, "There is not very much to learn in the city. It is time to walk in the forest again."[211]

His name means "dream."[212]

Will we accept the moody swings of frowning beech and bristling spruce? Or forgive the hawthorns their spiteful barbs? The hemlocks their Socratic poison?

Can we recognize a spark in any of these creatures that also lives in us? Or just change the way we think? After all, who is it that makes us ask questions?

Do we have it in ourselves to embrace those with whom we travel this earth? Even when, to our hasty eyes, they appear dark and lifeless as scorched headstones and driftwood?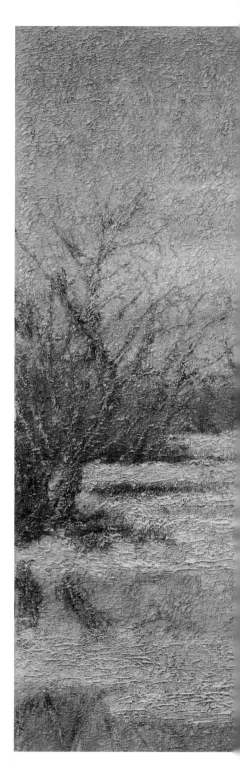

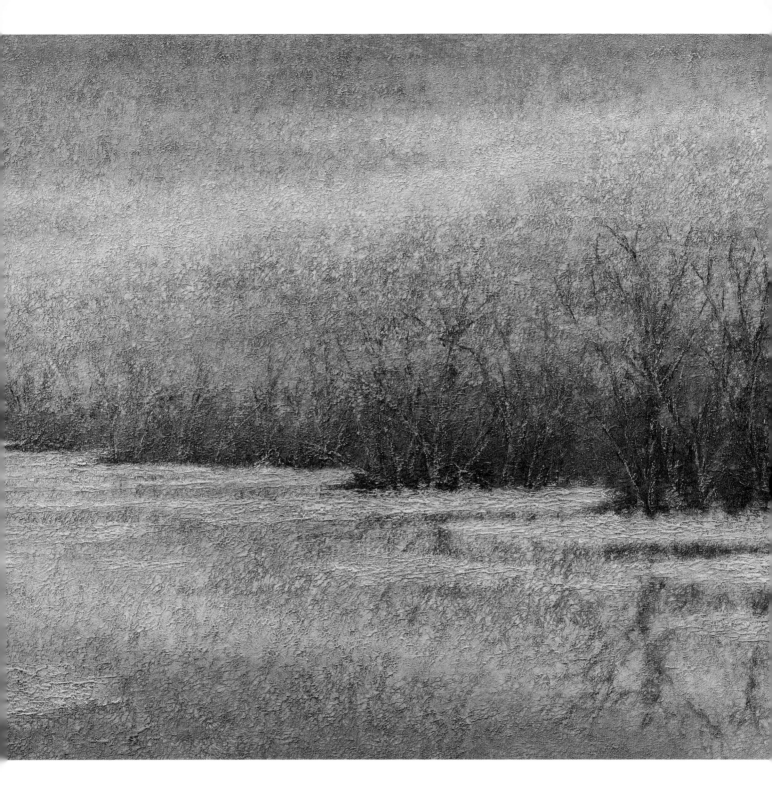

Swamp Cottonwood (*Populus heterophylla*), Black Willow (*Salix nigra*), Swamp Oak (*Quercus bicolor*), Pin Oak (*Q. palustris*), Mossycup Oak, Bur Oak (*Q. macrocarpa*), Red Maple (*Acer rubrum*)

○

Swamp Cottonwood (*Populus heterophylla*), Black Willow (*Salix nigra*), Swamp Oak (*Quercus bicolor*), Pin Oak (*Q. palustris*), Mossycup Oak, Bur Oak (*Q. macrocarpa*), Red Maple (*Acer rubrum*): In these chilling hours, do we perceive dusk or dawn? First light is slow to approach in winter, while dusk descends quickly, with cloaking darkness nipping at its heels.

Which way do we turn when challenged by our sorrows, fears, or urgencies? In the personal experience of author Jerry Sittser, "...the quickest way for anyone to reach the sun and light of day is not to run west, chasing after the setting sun, but to head east, plunging into the darkness until one comes to the sunrise."[213]

Throughout this collection, the trees have been depicted in a variety of landscapes because it is important to view them in context, not just as individual specimens. For their singular personalities are already clear. The particular qualities

of each have a way of asking an artist to guide the brush: the reserve of maple,[214] the hospitality of oak,[215] the erotic feminine qualities of willow[216] combined with her sense of freedom,[217] the temporal sense of cottonwood.[218]

The cottonwoods also told me of a dance, that you dreamed of a dance:

more than a hundred great blue herons riveted by the light of dawn . . .

—Barry Holstun Lopez[219]

Biotic diversity provides ecological stability across continents just as it does in this forlorn woodland bordering the icy banks of a river. Whether we view this equilibrium with a scientific or spiritual eye, it seems to be a rule of Creation.

. . . Creation is not a choice

but a necessity.

It is God's nature

to unfold time and space.

Creation is the extension of God.

Creation is God encountered in time and space.

Creation is the infinite in the garb of the finite . . .

—Pirke Avot 6:11[220]

That's why earth goddess cultures listen to all elements of landscapes as interdependent parts of whole ecological systems. W. H. Auden (1907–1973) spoke beautifully to this with the observation: "A culture is no better than its woods."

If we are to set out on this long forlorn waterway to reach a new level

of understanding, we will need to work with each other. The Innu of Labrador (indigenous North Americans of the Algonquian language group) have a wonderful entreaty for this kind of journey: *Tsheminupantaiats*. "Help us all to travel well together."

STILLNESS

Unlikely, we answer? Impractical? No less than the innocence of the oak or the longevity of the ginkgo.

What if, for the immeasurable period it takes to breathe deep or watch the stars meander, wherever time stands still, we could engage ourselves to experience something of no immediate practical use other than that which relates to the superfluous splendor of the tree? ❧

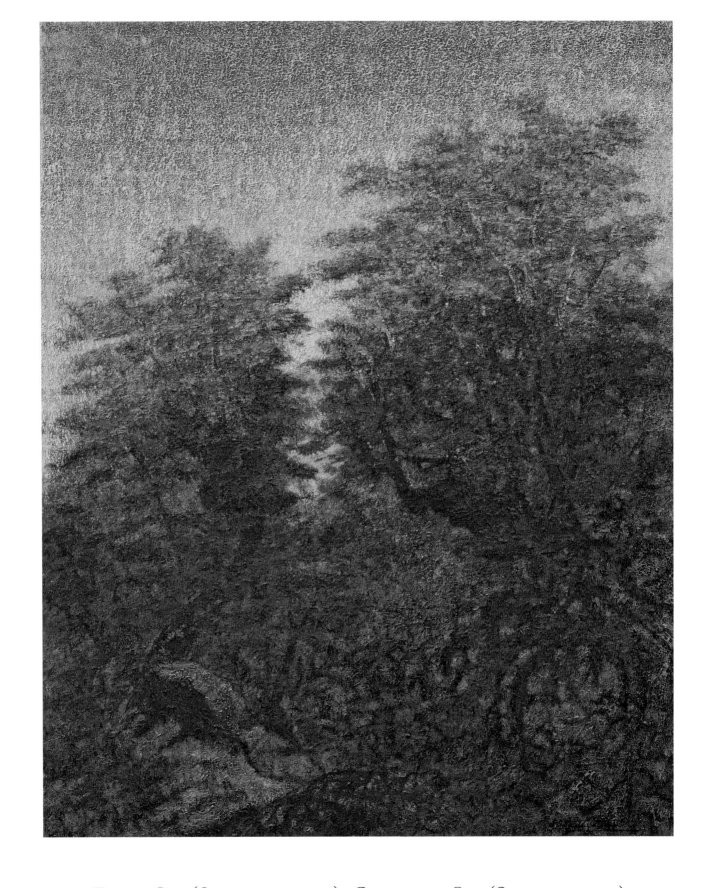

DWARF OAK (*QUERCUS PRINOIDES*), CHINQUAPIN OAK (*Q. MUEHLENBERGII*)

D warf Oak (*Quercus prinoides*), Chinquapin Oak (*Q. muehlenbergii*): Here, the woods and rocky ground surrender to the archetypal struggle between man and serpent that goes back beyond history. The anthropomorphic figure in the oak grapples with a snake, staring directly into its red eyes, although both are simply green things that grow. With the ability to transform itself by shedding its skin, the snake is a sign of rebirth and thus the cycle of life and death. It represents wisdom and defiance in some traditions, and in others it is equated with thunderstorms and lightning, forces able to bring about sudden and even frightening changes.

Perhaps we need some of that wisdom for transformation as we embark on quests for new technologies and alternative sources of energy. History has shown that we often fail to look at the hidden costs associated with novel and seemingly

attractive concepts. Is it due to the way we educate ourselves? Is it our systems of ethics or incentives? Or just the blinding lure of monetary rewards?

Look at biofuels, for example. Ethanol has been touted by some proponents as a heady alternative to fossil fuels. But there are downsides to making this replacement for gasoline from soybeans, sugarcane, or corn. "Corn requires large doses of herbicide and nitrogen fertilizer and can cause more soil erosion than any other crop. And producing corn ethanol consumes just about as much fossil fuel as the ethanol itself replaces."[221]

Planting corn for ethanol also takes land away from crops that contribute to the food supply, a trend that may indirectly be leading to food shortages around the world. "As farmers in the U.S. and Europe plant more corn in place of wheat to produce ethanol, the price of wheat has risen as supplies have tightened. Faced with higher wheat prices, people are substituting rice in their diets, particularly so in Africa. And, of course, the demand for ethanol as an alternative fuel is linked directly to the soaring price of oil. Moreover, the cost of rice production has increased significantly because fertilizer, transportation, and processing costs have shot up along with skyrocketing oil prices."[222]

And the world is in need of hopeful symbols, not those of hunger or despair.

> History has shown that we often fail to look at the hidden costs associated with novel and seemingly attractive concepts. Is it due to the way we educate ourselves? Is it our systems of ethics or incentives? Or just the blinding lure of monetary rewards?

Where do we find them, and what purpose might they serve?

Across cultures, whether in Australia or Africa, for indigenous or colonial "visiting" cultures, mythological symbols such as the snake are embedded in the landscapes that sustain us. They generate a resonant accord with the purest part of ourselves: serpents or dragons, falling stars or rising moons, feathers or mountains, earth, water, fire, whatever it is that strikes us in the gut by its representation of another aspect of our experience.

"It is by symbolism," concludes Thomas Merton (1915-1968), "that man enters effectively and consciously into contact with his own deepest self, with other men, and with God . . ."[223]

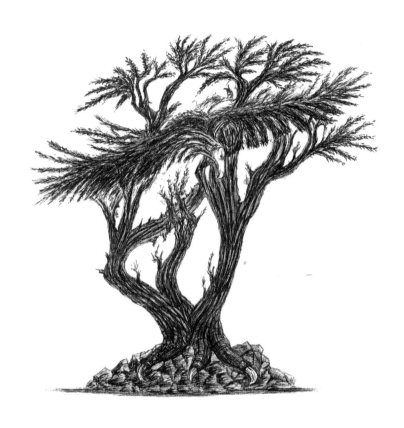

. . . serpents or dragons, falling stars or rising moons,

feathers or mountains, earth, water, fire, whatever

it is that strikes us in the gut by its representation

of another aspect of our experience.

Oh, hmm? ❧

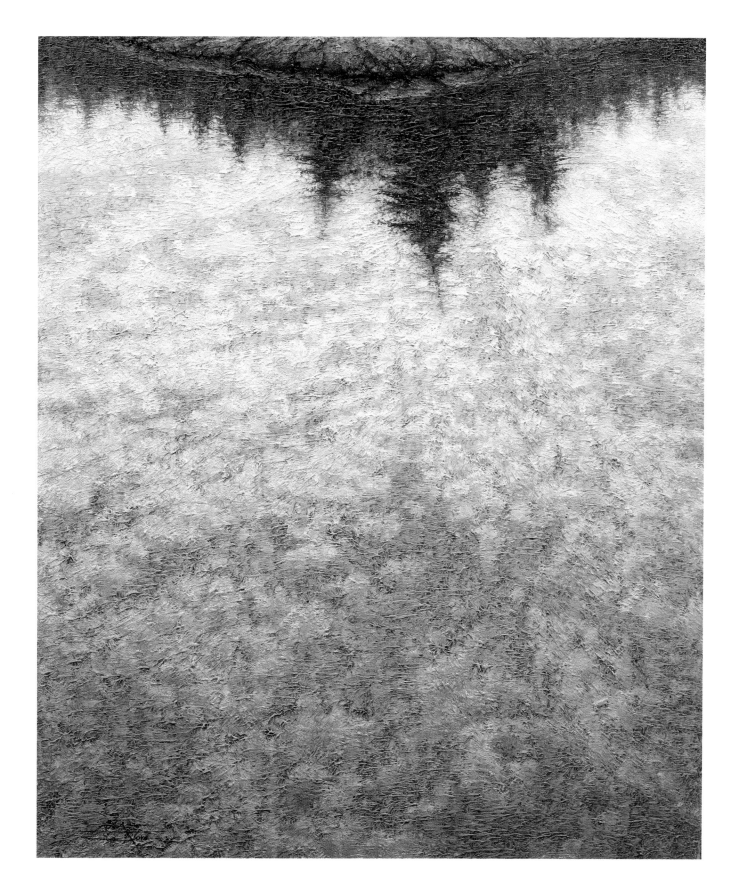

Black Spruce (*Picea mariana*)

Black Spruce (*Picea mariana*): Directly beneath the tallest spruce, created by the reflections of altocumulus in the bottom half of the painting, floats a subtle Pythagorean tetrakys in an interlocking pair of opposites. (The foremost trio of reflected spruces, in conjunction with the source of their image, would give us the six points of the same figure.) A combination of the upward "male" triangle correlated with fire and the downward "female" triangle correlated with water, this "hexagram" contains the symbols of the four elements in alchemy.[224] Known by various names in many cultures (the Great Seal, the Seal of Solomon, the Star of David, the fourth chakra symbol, or the Star, a universal shape associated in the Tarot with Adjustment and Justice[225]), the hexagram appears within the *I-Ching* of China and the yantra of India,

while in cabalism it represents the Sefirah Tifaret, "perfection."[226]

Mythologically, the downward triangle represents an obstacle we encounter as well as the divine guidance we must trust to overcome it. An upward triangle, with its highest point of unity, stands for inner wisdom and the challenge of surpassing the threshold of our obstacle. The sum of both is a thirteen-point figure, as is the equal-sided cross. In this context, it is a reference to transcendence: one point in the center like the axis of the compass, plus twelve points around it. It is akin to the center point represented by the forked tree of unity in the Sun dance of Plains peoples, surrounded by twelve stakes for "the twelve great nations on the Earth."[227]

Although often viewed negatively (like many symbols with multiple interpretations), one and twelve is also an archetypal figure of rebirth that takes us beyond time. (Buddhist stupas, for example, are topped with thirteen gold discs. For Tibetans, that number (four plus nine) becomes the forty-nine days after "death" when one has crossed into "the *Bardo*," "between two existences,"[228] the interim period of mourning during which consciousness dissociates from the body before reincarnation.) Beyond the twelve months in a year, beyond the twelve moons, the thirteenth is ever new and changing, yet ever the same—like the river. From the twelve signs of the zodiac plus the sun to the twelve apostles and Christ, its numerological significance is as ubiquitous as clouds.

And if unconcerned with temporal needs, might we glimpse anything more permanent, an untouchable part of ourselves brought forth by that untouchable aspect of the tree?

A sacred space where we can learn to bloom? ❧

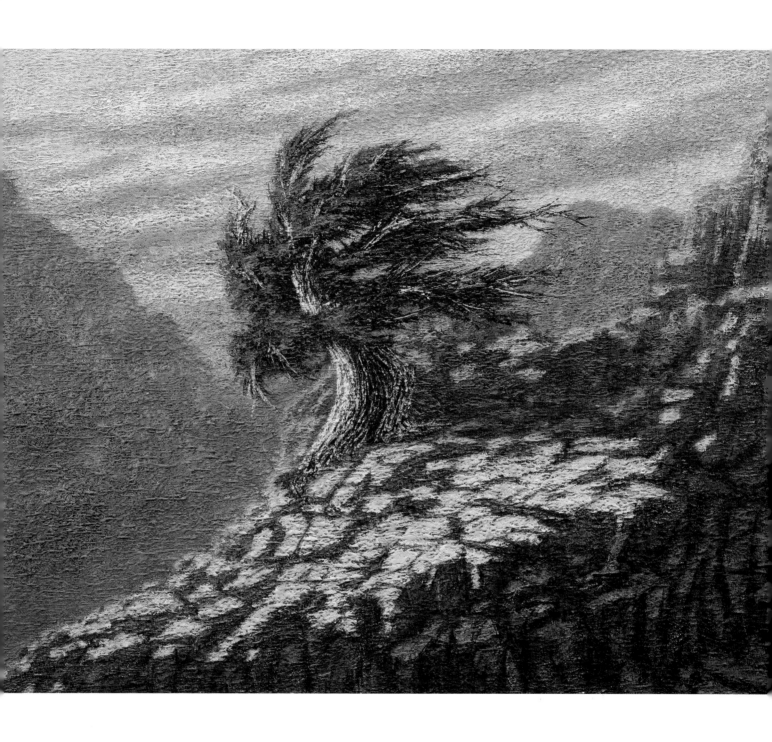

Dwarf Western Juniper (*Juniperus occidentalis*)

Dwarf Western Juniper (*Juniperus occidentalis*): A member of the cypress family (*Cupressaceae*), the genus *Juniperus* boasts an ancient common name that means "forever young,"[229] yet the cypress, ironically, is often thought of as a symbol of death and mourning.[230]

While painting this specimen in the eastern Sierra Nevada of the region now called Northern California, I supposed that, despite the gnarled and weathered appearance, it was probably young in spirit and deserving of its moniker. Preferring full exposure to the elements and arid, rocky soil conditions, its connotations of succor and protection come from the bristle-tipped needles guarding its berries, a symbolism that Christian traditions extend to the notion of chastity.[231] Being so hardy, no wonder so many junipers are commonly used as ornamentals by landscapers.

Doubtless there are other reasons as well. "Don't say a word against juniper bushes," says Thomas Pakenham wryly. "Without their pungent blue berries how could we flavour our gin?"[232]

How long has man related to trees that mirror traits he sees in himself? Long before Tolkien's Ents began shepherding the great trees of Middle Earth, we have found anthropomorphic comfort in even the most wind-ravaged and suffering of the Standing People.

This one shifted its shape for me, appearing as either a mountaineer clambering over the exposed rock or a seven-limbed Hindu goddess groping for a foothold—a fairly magnificent number with all its numerological allusions. For example, there are seven chakras in the Hindu system of spiritual and psychological development; seven levels of awareness in the Buddhist system; seven branches of the Menorah in Judaism, symbolizing the seven days of creation; seven supreme spirits in the ancient Parsi religion of Persia[233]; and seven rungs on the ladder of heavenly ascent climbed in various rituals of shamanic initiation.[234] The symbolism goes on and on, positive and negative, for seven is also equated with divine wrath and demons across cultures.

Maybe that's why there are so many points of view about whether or

not we should protect the wooded lands. And so many who strive to do so.

I hope there are others who don't mind trees.

—Norman Maclean[235]

For my part, though, discovering that scrambling figure in this steadfast tree offered a bit of hope for overcoming obstacles and pressing on toward the summit. Drawn to the movement in its motionless body, I thought it uncanny how the

juniper's triangular form resembles an upside-down V, resting on the wide flattened U-shape of sunlit rock, a graphic symbol for cultures native to North America of one not easily fooled, an unfaltering admirer of truth.[236]

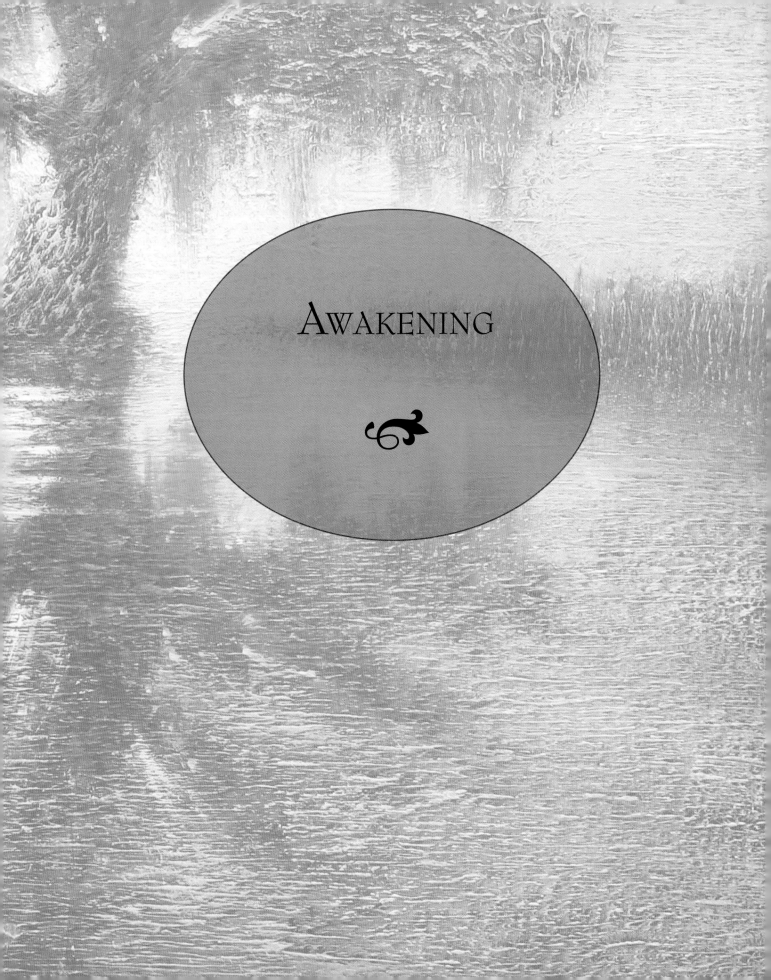

Awakening

Because sooner than we might admit, when the chance has drifted by like puffs of cottonwood treasure on a tepid breeze, the seasons move again.

Until, with the cackle of thawing ice, the trickle of snowmelt, the stirring of moss and groaning soil by the chalky yellow glow of another round moon; with sap-red branches, downy catkins, bursting buds, dangling aments, beaming for their perished seed—

—the earth is broken anew.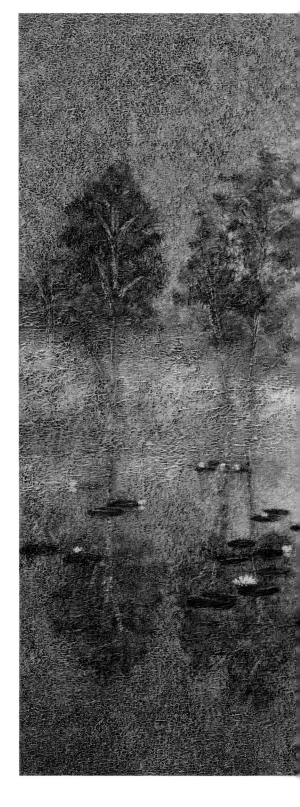

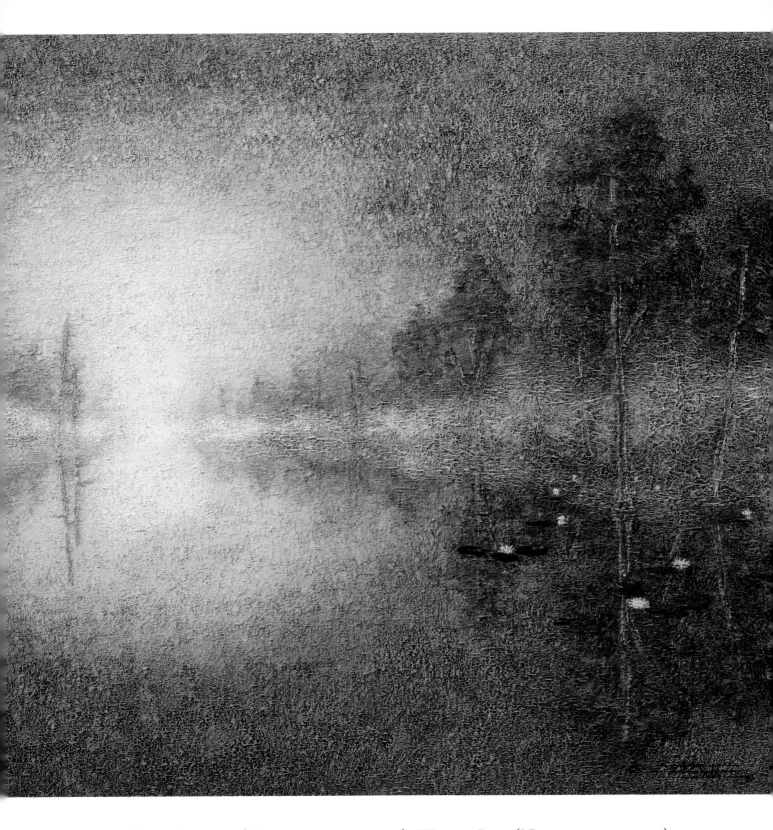

BALD CYPRESS (*TAXODIUM DISTICHUM*), WATER-LILY (*NYMPHAEA ODORATA*)

Bald Cypress (*Taxodium disti-chum*), Water-Lily (*Nymphaea odorata*): A riverine passage toward the light through buckled knees of cypress and vibrant white water-lilies. White suggests purity and holiness, but is also used for depicting death. Here though, the nine blossoms on either side of the painting's master path become a simple metaphor for wholeness and the circle, basking in the illumination of the sun. The hardy cypress has multiple meanings, too. While symbolizing death and burial in some cultures, in others it represents longevity and paradise.[237]

The hypnotic mist and diffuse light (of this place now called Tallahassee, Florida) caught my attention first, the dreamlike atmosphere. Perhaps that is the feeling Leonardo Da Vinci seeks to describe when he asks, "*Perche vede piv certa la cosa l'ochio ne' sogni che colla imaginatione, stando desto?*" ("Why does the eye see a thing more

clearly in dreams than awake?") [238] And Jung has a stirring reply: "The dream is a little hidden door in the innermost secret recesses of the soul . . . So flowerlike is it in its candor and veracity that it makes us blush for the deceitfulness of our lives."[239]

Could a vision like this, inspired by a waking experience, be a manifestation of energies that thread the past to our present, those that might enable us to dream the world we desire into being? One trick in looking at your dreams is to ask who is the subject, and who is the object. The answer is simple; they are one and the same.[240]

The universe is a dream dreamed by a single dreamer

where all the dream characters dream too.

—Arthur Schopenhauer[241]

Unifying the entire waterscape, the circular representation of the sun's radiance also represents the flow of energy ". . . in everything where power moves . . ." In the well-known words of Black Elk:

. . . the Power of the World always works in circles, and everything

tries to be round . . . The sky is round, and I have heard that the earth is round

like a ball, and so are the stars. The wind, in its greatest power, whirls. Birds

make their nests in circle, for theirs is the same religion as ours. The sun comes

forth and goes down again in a circle. The moon does the same, and both are

round. Even the seasons form a great circle in their changing, and always come

back again to where they were. The life of a man is a circle from childhood to

childhood, and so it is in everything where power moves . . .[242]

That striking power in the element of water seemed to flow right through me as I painted during the course of several evenings. It didn't surprise me to know that others have felt the same over the endless course of seasons.

It is said in the scriptures that water is a form of God . . .

—Sri Ramakrishna[243]

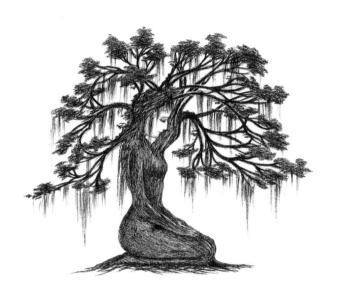

Could a vision like this, inspired by a waking experience, be a manifestation of energies that thread the past to our present, those that might enable us to dream the world we desire into being?

And that is good. ❧

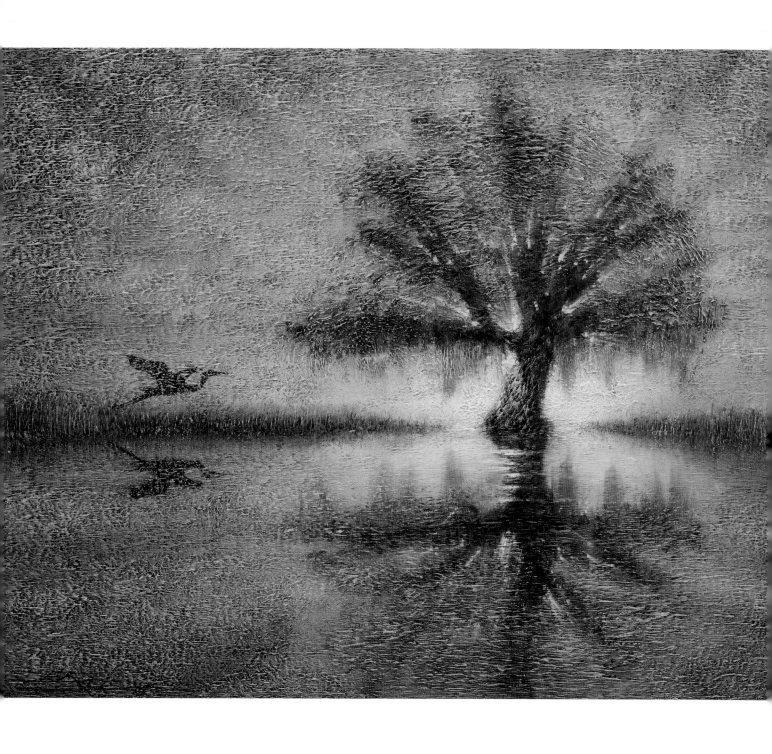

Live Oak (*Quercus virginiana*), Spanish Moss (*Tillandsia usneoides*)

L ive Oak (*Quercus virginiana*), Spanish Moss (*Tillandsia usneoides*): A tree that signifies liberty, draped with moss that represents maternal love. In response to the previous passage of awakening through cypress and water-lily, it is light from which all life awakens. A verse of rabbinic wisdom says concisely:

Better a single moment of awakening in this world
than eternity in the world to come. . .

The inner peace of the world to come
Is living in this world with full attention.[244]

The heron has taken flight to catch our attention, leading us higher toward the oak on the strength of her broad beating wings. With a range of historical associations, positive and negative, she rises here both as an omen of stormy weather and as a symbol of morning and new life. Her watery silhouette contains the same significance. But which is it that we are seeing, the silhouette or the water? Or both? Does that make it a "form of God," in Ramakrishna's terms, as well?

Water is round in a round receptacle and square in a square one, but water itself has no particular shape. People often forget this fact.[245]

Also guiding us toward the core of the painting are sunbeams lancing though the dense spreading foliage. Their power is universal.

These beams of Light are the essence of love, wishing our hearts to wakefulness.[246]

So, the solitary tree in this image becomes a Tree of Life. Paired with its reflection as an image of duality, a circle is formed, a symbol of "the spirit in its original form" for indigenous cultures of North America,[247] and ultimately a symbol of the human psyche.[248] If you look closely, it is divided into eighths like the Buddhist Wheel of Dharma, or a figurative lotus blossom, or the Pååhra (dream badges) of the Lenape tribe (Eastern Algonquin), which are believed to chronicle a person's recollections of visionary dreams.[249]

The eight points on the circumference are synonymous with the four cardinal directions and four secondary directions, like the eight points on the Ojibwa *aki*, a circular image that represents the world.[250] This is similar to cross-cultural symbols of the five directions (found, for example, in coiled shallow baskets of the Apache,[251] the quill-worked leather tipi ornaments of the Arapaho,[252] or the coiled plaques made

from galleta grass and yucca leaves of the Hopi[253]). The ninth direction is the central point, just as, with the connotations of the number five, the fifth direction becomes the central point of the four cardinal directions. Cultures that see themselves as ". . . a mere part of Creation . . ." (in the words of Chief Oren Lyons) know that when we address ourselves to the cardinal directions from the center point, to the circle that is the sky and the circle that is the land, the whole world becomes sacred—and we cannot be anything other than an inextricable part of this place.

Joseph Campbell observes that for indigenous peoples of this continent to have seen a sacred creature like the buffalo treated as an "it," instead of as a "thou," representing an acknowledgement of its holiness, was sacrilege. They ". . . addressed all of life as a 'thou'—the trees, the stones, everything. You can address anything as a 'thou,' and if you do it, you can feel the change in your own psychology."[254]

Those earth goddess cultures' traditions that have survived still do view all life as sacred. What might that mean, to sanctify the world in which we live? Campbell suggests:

> *To live in sacred space is to live in a symbolic environment where*
> *spiritual life is possible, where everything around you speaks of exaltation of*
> *the spirit.*[255]

If you open your senses, if you gaze and listen to that still small voice in your heart, you can feel the answer. The rough equivalent in India is *shraddha*, which translates literally as "that which is placed in the heart."[256] Indian scripture is quite clear about its power, declaring simply: *A person is what his shraddha is.*[257]

Christian traditions observe that it applies to the heart of man ruled by avarice

or fear, too: *For as he thinketh in his heart, so is he. . .*[258]

This is implicit in what we focus our energies on, in everything we do. It fuels our "deep driving desire."[259] It informs our thoughts, and thus our destiny.

Awakening to this level, we might be better able to return our attentions to the earth that sustains us, to dream a new reality into being.

"The world is as you dream it," explains a Shuar elder of the Ecuadorian rainforest. "Your people dreamed of huge factories, tall buildings, as many cars as there are raindrops in this river. Now you begin to see that your dream is a nightmare."[260]

So what can we do to escape the nightmare? We might ask him: How can we change the destructive ways we have learned to live?

And his reply? "All you have to do is change the dream . . . You need only plant a different seed, teach your children to dream new dreams."[261]

You should water your children like you water a tree, say the Hopi.[262]

It has always been possible, offers *The Dhammapada*: *Our life is shaped by our mind; we become what we think.*[263]

Still, dreaming is profoundly simple and begins with each one of us. It is a way we can tap our creative selves to relearn an ancient story of wisdom; a way we can sanctify the land and sky and waters, by recognizing that—yes, we are nature, too.

APPENDIX I
Sample Questions for Discussions and Activities

Educators will find the second narrative's notes about the paintings and trees useful for a host of subjects: art, conservation, creative writing, ecology, english, geography, history, horticulture, mythology, native studies, science (biology, physics), and social studies.

The following sample questions may be used as starting points from which classroom activities and lessons can be designed. Along with the carefully researched text and sources, these explore crucial issues for cross-curricular projects that may include several disciplines.

In the author's terms, what is an essential aspect of earth's largest plants that is often taken for granted?
What is complex about humans' relationship with forests?
Why have we historically decimated forests for material gain?
What integral part of ourselves is nurtured by the very existence of forests?
What part of the planet may be healed by trees?
How does healing the planet relate to our physical health and well-being?
What are examples of things humans require that come from trees?
How can we create and support the balance between using trees for products that people need and helping forest environments to thrive?
Should we be responsible for every ecosystem? Why?
What is ecological "balance"?
What is a "watershed"? How is it affected by its forests?
What are examples of our inextricable bond with the environment?
How can we teach ourselves to examine this bond in new ways?
Whose environment is it? Should we think of it as "ours"?
What are some ways we can examine the value of woodlands, parks, and forests?
Is the extraction of "natural" resources more important than letting them go to waste?
What does it mean to "develop" natural resources? Why should we care how we use them?
What does it mean to look at the impact of the "development" of natural resources?
What is the meaning of "sustainability"?
What is the meaning of "renewable"?
How can we tell if a resource is renewable or not?
Why are natural landscapes and their trees so vital to us?
Can you name the different parts of trees?
What is the meaning of "nurturing"? What part of trees contains this quality?
How can something as mundane as a tree really nurture us?
What is the importance of horticulture?
What is the difference between the "art" and "science" of growing plants?
What is so necessary about the old specimens found in city parks and along parkways?
What is the purpose of planting ornamental flowering varieties around our dwellings?
How can these ornamentals or old city specimens affect our spiritual selves? How can they affect our vitality?
How does the presence of trees impact the mind-body system?
Could the influence of trees vary, depending on the season?
How would you plan a garden with healing qualities?
Should we care about forests that have not yet been spoiled or razed?
What does the author mean by "untouchable"?
What are some ways that we might discover the "untouchable" aspect of ourselves?
Can you suggest some reasons why the author tells the story in nine chapters?
What are some possible meanings of the chapter titles?
What "path" are we on as a culture? Does this path have a heart? What does that mean?
Are we running out of time to be traveling along this path?
What are some of the cultures that still possess the understanding of how to live in accord with land and sea and sky? How might we learn from them?
What are the commercial uses of trees in your area? What are the noncommercial uses?
Can you identify some of the costs and benefits of the trees in your area? Are there any benefits that have been overlooked or wasted by commercial enterprises?
How can you support businesses as well as the trees and ecological systems from which they benefit?
If we only look at trees as commodities, how is that different from the way we view the rest of what we call "resources" on this planet?
What are some indicators that our economic perspective on trees may have failed?
Are we capable of changing the way we view trees?
What are some reasons why we should consider trying to change? How do we accomplish this?
How might trees be used to heal polluted environments?
How are we "inseparable" from all green things that grow?
What is photosynthesis?
What does it take for a seed to germinate? What is needed for a plant to grow?
What is chlorophyll?
Can you identify the trees in your neighborhood?
What do you find interesting about the pen and inks in each chapter?
What is important about tree diversity in a forest?
How would you design a forest in your community? How might this impact the health of your community?
How do we sanctify the land we live with?

APPENDIX II
List of Paintings by Common Name (*Genus species*); *Title*

Frontispiece; American Linden, Basswood, Lime (*Tilia americana*); *The Valley Spirit*

Chapter 1. Blossoms
Black Cherry (*Prunus serotina*); *Water Snake*
Common Apple (*Malus communis*); *Orchard*
Red Maple, Swamp Maple, Water Maple (*Acer rubrum*); *Swamp Maples*

Chapter 2. Thresholds
Flowering Dogwood, Flowering Cornel (*Cornus florida*), Black Oak (*Quercus velutina*), Red Pine (*Pinus resinosa*); *Moongate, Dogwoods*
American Beech (*Fagus grandifolia*); *Grandmother Beech*

Chapter 3. The Journey
Sugar Maple (*Acer saccharum*); *Pollen Path*
White Birch, Paper Birch (*Betula papyrifera*); *Birches*
Ponderosa Pine, Yellow Pine (*Pinus ponderosa*); *Ponderosa*

Chapter 4. Dream Time
Black Locust (*Robinia pseudoacacia*), Water-Lily (*Nymphaea odorata*); *Red Lily & Locusts*
Pecan (*Carya illinoinensis*); *The Old Grove*
Buttonwood, Plane Tree, Sycamore (*Platanus occidentalis*); *The Curious Sycamore*

Chapter 5. Teachers
White Pine (*Pinus strobes*); *Wailing Pines*
Atlas Cedar, Atlantic White Cedar (*Cedrus atlantica*), Red Cedar (*Juniperus virginiana*); *Brash Cedars*
Bald Cypress (*Taxodium distichum*), Australian Pine (*Casuarina equisetifolia*), Coconut Palm (*Cocos nucifera*); *Islands*
Weeping Willow (*Salix babylonica*); *Laughing Willows*

Chapter 6. Autumn
White Oak (*Quercus alba*); *Oak Dreamer*
White Oak (*Quercus alba*), Red Oak (*Q. rubra*), Scrub Oak (*Q. ilicifolia*); *Serpent Moon*
Shagbark Hickory (*Carya ovata*), Red Maple (*Acer rubrum*), White Oak (*Quercus alba*), Scrub Oak (*Q. ilicifolia*); *River Goddess*
Norway Spruce (*Picea abies*); *Burial Grounds*

Chapter 7. Darkness
White Pine (*Pinus strobes*), Red Pine (*P. resinosa*), Scotch Pine, Scots Pine (*P. sylvestris*); *Pine Nocturne*
White Poplar (*Populus alba*); *Poplar Path*
American Linden, Basswood, Lime (*Tilia americana*); *Sentinel*
Swamp Cottonwood (*Populus heterophylla*), Black Willow (*Salix nigra*), Swamp Oak (*Quercus bicolor*), Pin Oak (*Q. palustris*), Mossycup Oak, Bur Oak (*Q. macrocarpa*), Red Maple (*Acer rubrum*); *River in Winter*

Chapter 8. Stillness
Dwarf Oak (*Quercus prinoides*), Chinquapin Oak (*Q. muehlenbergii*); *Oak Serpent*
Black Spruce (*Picea mariana*); *Spruce Island*
Dwarf Western Juniper (*Juniperus occidentalis*); *Mountaineer*

Chapter 9. Awakening
Bald Cypress (*Taxodium distichum*), Water-Lily (*Nymphaea odorata*); *Cypress Passage*
Live Oak (*Quercus virginiana*), Spanish Moss (*Tillandsia usneoides*); *Live Oak*

APPENDIX III
List of Pen and Inks by Chapter and Title

Chapter 1. Blossoms
Flowering Cherry (*Prunus gracensis*)
Chapter 2. Thresholds
Contrary Cypress (*Cupressus dipherinpoinsavuii*)
Chapter 3. The Journey
Bald Juniper (*Juniperus raptora*)
Chapter 4. Dream Time
Prying Birch (*Betula eafestroppensis*)
Chapter 5. Teachers
Weeping Willow (*Salix sheddinaphuterii*)
Chapter 6. Autumn
Sentinel Oak (*Quercus enguardia*)
Chapter 7. Darkness
Prowling Cedar (*Cedrus ungrija guarii*)
Chapter 8. Stillness
Soaring Cypress (*Cupressus kondoris endangerensis*)
Chapter 9. Awakening
Bowed Oak (*Quercus diphidensis*)

SELECTED BIBLIOGRAPHY

Arrien, Angeles, *The Tarot Handbook: Practical Applications of Ancient Visual Symbols*, Tarcher/Putnam, New York, 1997.

Art, Pamela B., project editor, *The Wise Garden Encyclopedia*, HarperCollins, New York, 1990 (Originally published in 1970, E. L. D. Seymour, Editor).

Benyus, Janine M., *Biomimicry: Innovation Inspired by Nature*, Harper Perennial, New York, 2002.

Biedermann, Hans, *Dictionary of Symbolism: Cultural Icons and the Meanings Behind Them*, translated by James Hulbert, Meridian, New York, 1994.

Birren, Faber, *Color and Human Response*. John Wiley and Sons, New York, 1978.

Boom, B. K., and Kleijn, H., *The Glory of the Tree*, Doubleday, New York, 1966.

Borgenicht, David, Editor, *Native American Wisdom: Photographs by Edward S. Curtis*, Running Press, Philadelphia, 1994.

Brown, Joseph Epes, *The Sacred Pipe: Black Elk's Account of the Seven Rites of the Oglala Sioux*, University of Oklahoma Press, Norman, OK, 1953.

Burnie, David, *Tree*, Knopf, New York, 1988.

Campbell, Joseph, *The Hero with a Thousand Faces*, MJF Books, Bollingen Foundation, New York, 1949.

Campbell, Joseph, *The Power of Myth*, with Bill Moyers, Doubleday, New York, 1988.

Campbell, Joseph, *Reflections on the Art of Living: A Joseph Campbell Companion*, Diane K. Osbon, editor, HarperCollins, New York, 1991.

Cirlot, J. E., *A Dictionary of Symbols*, second edition, translated by Jack Sage, Dover Publications, Mineola, NY, 2002 (originally published by Philosophical Library, New York, 1971).

Collingwood, G. H., and Brush, Warren D., *Knowing Your Trees*, American Forestry Association, Washington, D.C., 1955.

Connick, Charles J., *Adventures in Light and Color*, Random House, New York, 1937.

Diamond, Jared, *Guns, Germs, and Steel: The Fates of Human Societies*, W. W. Norton & Co., New York, 1999.

Eliade, Mircea, *Shamanism*, translated by Willard R. Trask, Princeton University Press, Princeton, NJ, 2nd paperback edition, 2004.

F. W. L. [full name unknown], *The Language of the Flowers*, Beric Press, Crawley, England, 1979.

Feininger, Andreas, *Trees*, Rizzoli, New York, reprint edition, 1991.

Garrett, Laurie, *The Coming Plague: Newly Emerging Diseases in a World Out of Balance*, Penguin, New York, 1995.

Giono, Jean, *The Man Who Planted Trees*, Chelsea Green, Chelsea, VT, 1985 (originally published in *Vogue* under the title "The Man Who Planted Hope and Grew Happiness," 1954).

Harner, Michael, *The Way of the Shaman*, HarperCollins, San Francisco, third edition, copyright 1980, 1990 (originally published by Harper & Row, 1980).

Harvey, Andrew, editor, *The Essential Mystics: Selections from the World's Great Wisdom Traditions*, HarperCollins, New York, 1996.

Hawken, Paul, *The Ecology of Commerce: A Declaration of Sustainability*, HarperBusiness, New York, 1994.

Kimbrell, Andrew, editor, *Fatal Harvest: The Tragedy of Industrial Agriculture*, Foundation for Deep Ecology, Washington, D.C., 2002.

Lao, Tzu, *Tao Teh Ching*, translated by John C. H. Wu, Shambhala, Boston, 1989 (copyright 1961 St. John's University, New York).

Lemmon, Robert S., *The Best Loved Trees of America*, The American Garden Guild and Doubleday, New York, 1952.

Neihardt, John G., *Black Elk Speaks*, University of Nebraska Press, 1961.

Norberg-Hodge, Helena, *Ancient Futures: Learning from Ladakh*, Sierra Club Books, San Francisco, 1991.

Owusu, Heike, *Symbols of Native America*, Sterling Publishing, New York, 1997.

Pakenham, Thomas, *Remarkable Trees of the World*, W. W. Norton & Co., New York, 2002.

Perkins, John, *The Secret History of the American Empire: Economic Hit Men, Jackals, and the Truth About Global Corruption*, Dutton, New York, 2007.

Petrides, George A., *Peterson First Guide to Trees: A Simplified Field Guide to the Trees of North America*, illustrated by Olivia Petrides and Janet Wehr, Houghton Mifflin, Boston, 1993.

Pilger, John, *A Secret Country: The Hidden Australia*, Alfred A. Knopf, New York, 1991.

Plotkin, Mark J., *Tales of a Shaman's Apprentice: An Ethnobotanist Searches for New Medicines in the Amazon Rain Forest*, Penguin, New York, 1994 (originally published by Viking Penguin, New York, 1993).

Quinn, Daniel, *Ishmael*, Bantam/Turner, New York, 1992.

Taylor, Colin F., *The American Indian*, Salamander, London, 2002.

Weisman, Alan, *Gaviotas: A Village to Reinvent the World*, Chelsea Green Publishing, White River Junction, VT, 1998.

Witcombe, Christopher L. C. E., "Sacred Places," http://witcombe.sbc.edu/sacredplaces/trees.html, Department of Art History, Sweet Briar College, VA, 1998.

ENDNOTES

1 Hans Biedermann, *Dictionary of Symbolism: Cultural Icons and the Meanings Behind Them*, translated by James Hulbert, Meridian, New York, 1994, p. 66.

2 F. W. L. [full name unknown], *The Language of the Flowers*, Beric Press, Crawley, England, 1979, p. 5.

3 Heike Owusu, *Symbols of Native America*, Sterling Publishing, New York, 1997, pp. 126–127.

4 Kenneth Grahame, *The Wind in the Willows*, Charles Scribner's Sons, New York, third copyright 1953, p. 4.

5 Ibid., p. 10.

6 Michael Harner, *The Way of the Shaman*, HarperCollins, San Francisco, third edition, copyright 1980, 1990 (originally published by Harper & Row, 1980), p. 58.

7 Ibid.

8 *Apples and More, Apple Facts*, University of Illinois Extension, http://www.urbanext.uiuc.edu/apples/facts.html.

9 *The American Heritage Dictionary of the English Language*, Houghton Mifflin, Boston, New York, third edition copyright 1996, 1992, p. 873.

10 "Virus Implicated In Colony Collapse Disorder In Bees," *ScienceDaily*, http://www.sciencedaily.com /releases/2007/09/070906140803.htm.

11 Laurie Garrett, *The Coming Plague: Newly Emerging Diseases in a World Out of Balance*, Penguin, New York, 1995, p. 51.

12 Ibid.

13 Ibid.

14 John Perkins, *The Secret History of the American Empire: Economic Hit Men, Jackals, and the Truth About Global Corruption*, Dutton, New York, 2007, p. 262.

15 Paul Hawken, *The Ecology of Commerce: A Declaration of Sustainability*, HarperBusiness, New York, 1994, p. 26.

16 "Honey Bee Die-off Alarms Beekeepers, Crop Growers And Researchers," *ScienceDaily*, http://www.sciencedaily.com/releases/2007/04/070422190612.htm.

17 Michael Pollan, "Our Decrepit Food Factories," *New York Times Magazine*, http://www.nytimes.com/2007/12/16/magazine/16wwln-lede-t.html?_r=3&pagewanted=2&oref=slogin&oref=slogin, p. 2.

18 Wendell Berry, "Hope," in *Fatal Harvest: The Tragedy of Industrial Agriculture*, Andrew Kimbrell, editor, Foundation for Deep Ecology, Washington, D.C., 2002, p. 373.

19 Ibid.

20 Faber Birren, *Color and Human Response*, John Wiley and Sons, New York, 1978, p. 5.

21 J. E. Cirlot, *A Dictionary of Symbols*, second edition, translated by Jack Sage, Dover Publications, Mineola, NY, 2002 (originally published by Philosophical Library, New York, 1971), p. 14.

22 *Dictionary of Symbolism*, op. cit., p. 104.

23 Ibid., p. 16.

24 Charles J. Connick, *Adventures in Light and Color*, Random House, New York, 1937, p. 220.

25 Ibid.

26 Eugene Field, cited in *The Home Book of Quotations*, Burton Stevenson, editor, Dodd, Mead & Co., 1934, p. 260.

27 *Rig Veda* X, 129, *The Vedic Experience: Mantramanjari*, translated by Raimundo Panikkar, University of California Press, Berkeley and Los Angeles, 1977.

28 Joseph Epes Brown, *The Sacred Pipe: Black Elk's Account of the Seven Rites of the Oglala Sioux*, University of Oklahoma Press, Norman, OK, 1953, p. 123.

29 *Symbols of Native America*, op. cit., p. 21.

30 Eknath Easwaran, translator, in *The Upanishads*, Nilgiri Press, Tomales, California, 1987, p. 16.

31 Deepak Chopra, *Quantum Healing: Exploring the Frontiers of Mind / Body Medicine*, Bantam, New York, 1990, p. 92.

32 Ibid, p. 205.

33 Albert Einstein, *The Expanded Quotable Einstein*, Alice Calaprice, editor, Princeton University Press, Princeton, NJ, 2000, (copyright Princeton University Press and The Hebrew University of Jerusalem,) p. 295.

34 Paul, *I Corinthians*, 1: 25, King James Bible.

35 *Native American Wisdom: Photographs by Edward S. Curtis*, David Borgenicht, editor, Gregory C. Aaron, text researcher, Running Press, Philadelphia, 1994, p. 96.

36 Joseph Campbell, in *Reflections on the Art of Living: A Joseph Campbell Companion*, Diane K. Osbon, editor, HarperCollins, New York, 1991, pp. 143–144.

37 http://www.wyrdology.com/festivals/easter/dogwood.html.

38 http://www.geocities.com/Area51/Shire/3951/dryadart.html.

39 *The Language of the Flowers*, op. cit., p. 8.

40 *A Dictionary of Symbols*, op. cit., pp. 275–276.

41 Jared Diamond, *Guns, Germs, and Steel: The Fates of Human Societies*, W.W. Norton & Co., New York, 1999, pp. 44–45.

42 Mark J. Plotkin, *Tales of a Shaman's Apprentice,: An Ethnobotanist Searches for New Medicines in the Amazon Rain Forest*, Penguin, New York, 1994 (originally published by Viking Penguin, New York, 1993), p. 273.

43 http://www.abundantforests.org/renew.html cited in, *Forest Resources of the United States, 2002*, U. S. Forest Service, North Central Research Station, St. Paul, MN, 2004. http://www.ncrs.fs.fed.us/pubs/viewpub.asp?key=1987.

44 http://www.afandpa.org/Content/NavigationMenu/Forestry/Forestry_Facts_and_Figures/hist_sketch.pdf. Sources cited: MacCleery, Douglas W., *American Forests: A History of Resilience and Recovery*, 1994; Smith, Brad W. et al., *Forest Resources of the United States*, USDA Forest Service, 2001.

45 Ibid.

46 http://www.cmu.edu/greenpractices/recycling/paper.html. Source cited: The Public Recycling Officials of Pennsylvania, *Developing a Waste Reduction and Recycling Program for Commercial, Industrial and Municipal Establishments*, May 1995.

47 Ibid.

48 Ibid.

49 Jeff Goodell, "The Prophet of Climate Change: James Lovelock, *Rolling Stone*, http://www.rollingstone.com/politics/story/16956300/the_prophet_of_climate_change_james_lovelock, posted Oct. 17, 2007.

50 Bill McKibben, "Carbon's New Math," *National Geographic*, October 2007, p. 36.

51 http://www.sustainabilitank.info/category/global-warming, posted January 16, 2008.

52 Laurie David, "What Are They Waiting For," *Stop Global Warming Virtual March*, StopGlobalWarming.org, e-mail letter January 24, 2008.

53 http://www.whataretheywaitingfor.com/facts.html, prepared and paid for by League of Conservation Voters, January 25, 2008.

54 Matt Vella, "Using Nature as a Design Guide," *BusinessWeek*, http://www.businessweek.com/innovate/content/feb2008/id20080211_074559.htm, posted February 11, 2008.

55 Alan Weisman, *Gaviotas: A Village to Reinvent the World*, Chelsea Green Publishing, White River Junction, VT, 1998, p. 104.

56 Ibid., p. 167.

57 Ibid., p. 175.

58 Ibid., p. 186.

59 Paul Kaihla, "The Village That Could Save the Planet: How Two Men Plan to Extend the Ecological Miracle That Is Gaviotas, Columbia, Across the Rest of the Third World," *Business 2.0 Magazine*, http://money.cnn.com/2007/09/26/technology/village_saving_planet.biz2, posted September 27, 2007.

60 Richard E. White and Gloria Eugenia Gonzalez Marino, "Las Gaviotas: sustainability in the tropics," World Watch Institute, May 1, 2007, cited at http://www.accessmylibrary.com/coms2/summary_0286-31746133_ITM.

61 Dr. Seuss, *The Lorax*, Random House, New York, 1971, p. 58 (unnumbered pages).

62 Helena Norberg-Hodge, *Ancient Futures: Learning from Ladakh*, Sierra Club Books, San Francisco, 1991, p. 5.

63 Ibid., p. 4.

64 Ibid., p. 5.

65 Ibid., p 191.

66 Anne Sexton, *The Complete Poems, Anne Sexton*, Houghton Mifflin, Boston, 1999, excerpted from "What the Bird with the Human Head Knew."

67 Lao Tzu, *Tao Teh Ching*, translated by John C. H. Wu, Shambhala, Boston, 1989 (copyright 1961 St. John's University, New York), chapter 8, p. 17.

68 *Isha Upanishad*, *The Upanishads*, op. cit., p. 208.

69 Mircea Eliade, *Shamanism: Archaic Techniques of Ecstasy*, translated by Willard R. Trask, Princeton University Press, Princeton, NJ, second paperback edition, 2004 (copyright 1964, renewed 1994), p. 266.

70 Joseph Campbell, *The Hero with a Thousand Faces*, MJF Books, Bollingen Foundation, New York, 1949, p. 213.

71 Ibid., p. 212 fn.

72 *Shamanism*, op. cit., p. 271.

73 http://www.jungcircle.com/archiveA.html.

74 Michael Vescoli, *The Celtic Tree Calendar: Your Tree Sign and You*, Souvenir Press, London, 1999, pp. 47–51.

75 *The Hero with a Thousand Faces*, op. cit., p. xxi.

76 *A Dictionary of Symbols*, op. cit., p. 197.

77 Angeles Arrien, *The Tarot Handbook: Practical Applications of Ancient Visual Symbols*, Tarcher/Putnam, New York, 1997, p. 41-42.

78 Ibid. Italics in original.

79 Transcribed from a "hand-lettered sign at the entrance to the Fifth Squadron air base, Skardu," cited in Greg Mortenson and David Oliver Relin, *Three Cups of Tea*, Penguin, New York, 2006, p. 83.

80 *A Dictionary of Symbols*, op. cit., p. 351.

81 *The Bhagavad Gita*, translated by Eknath Easwaran, Translator, Tomales, CA, 1999, p. 106, ch. 6: v. 19.

82 Alberto Villoldo, *The Four Insights: Wisdom, Power, and Grace of the Earthkeepers*, Hay House, Carlsbad, CA, 2006, p. 13.

83 *Symbols of Native America*, op. cit., p. 257.

84 http://trailingincas.info/empire.php.

85 Dr. George M. Foster, in *Funk & Wagnalls Standard Dictionary of Folklore, Mythology, and Legend*, edited by Maria Leach, Funk & Wagnalls, New York, 1972 (original published 1949), p. 510.

86 Michael N. Nagler, "Reading the Upanishads," in *The Upanishads*, op. cit., p. 284.

87 Guy A. Zona, *The Soul Would Have No Rainbow if the Eyes Had No Tears and Other Native American Proverbs*, Touchstone, New York, 1994, p. 59.

88 *Katha Upanishad*, *The Upanishads*, op. cit., p. 89, I:iii; 14.

89 Carlos Castaneda, *The Teachings of Don Juan: A Yaqui Way of Knowledge*, Ballantine, New York, 1968, p. 105–106.

90 *The Wise Garden Encyclopedia*, Pamela B. Art, project editor, HarperCollins, New York, 1990 (originally published in 1970, E. L. D. Seymour, Editor) pp. 127–128.

91 *Shamanism*, op. cit., p. 270.

92 *The Language of the Flowers*, op. cit., p. 2.

93 Chief Seattle (Seathl) in Joseph Campbell, *The Historical Atlas of World Mythology, Volume I: The Way of the Animal Powers, Part 2: Mythologies of the Great Hunt*, Harper & Row, New York, 1988, p. 251.

94 John Pilger, *A Secret Country: The Hidden Australia*, Alfred A. Knopf, New York, 1991, pp. 24–25.

95 Ibid., p. 23.

96 Ibid., p. 25.

97 Ibid.

98 *Tao Teh Ching*, op. cit., chapter 6, p. 13.

99 The painting's title is also inspired by Lao Tzu's *Tao Teh Ching*, cited in *The Essential Mystics, Selections from the World's Great Wisdom Traditions*, Andrew Harvey, editor, HarperCollins, New York, 1996, p. 19.

100 Kagaba myth, in *The Essential Mystics*, op. cit., p. 5.

101 Caroline Arnold, *On the Brink of Extinction: The California Condor*, Harcourt Brace & Co., New York, 1993, p. 41.

102 Talia Shafir, "Keepers of the Prophecy—Past Lives in Peru," http://www.newagetravel.com/keepers-prophecy.shtml.

103 http://www.theforestpath.com/legend.htm.

104 *The Four Insights*, op. cit., p. 17.

105 *The Tarot Handbook*, op. cit., p. 34.

106 *The Sacred Pipe,* op. cit., p. 39n.

107 *The Tibetan Book of the Dead: Liberation Through Understanding in the Between* translated by Robert A. F. Thurman (composed by Padma Sambhava; discovered by Karma Lingpa), Bantam Books, New York, 1994, p. 186.

108 *The Upanishads*, op. cit., pp. 10–11.

109 Max Ehrmann, *Desiderata*, copyright 1927 (published later by Indiana Publishing), http://www.fleurdelis.com/desiderata.htm.

110 *Dictionary of Symbolism*, op. cit., p. 350.

111 *Guns, Germs, and Steel,* op. cit., p. 115.

112 Ruth Beebe Hill, *Hanta Yo*, Doubleday, New York, 1979, p. 818.

113 *The Way of the Shaman*, op. cit., p. 50.

114 "Aborigine Song," in *The Essential Mystics*, op. cit., p. 9.

115 *Dictionary of Symbolism*, op. cit., p. 250.

116 Ibid.
117 *A Dictionary of Symbols*, op. cit., p. 247.
118 *The Sacred Pipe,* op. cit., p. 74.
119 Jalâluddin Rûmî, excerpt from the *Rubaiyat: The Essential Mystics*, op. cit., p. 162.
120 *Dictionary of Symbolism*, op. cit., p. 158.
121 *The Tarot Handbook*, op. cit., p. 150.
122 *Symbols of Native America*, op. cit., p. 17.
123 *The Sacred Pipe,* op. cit., p. 59.
124 *Symbols of Native America*, op. cit., pp. 282–283.
125 Ibid., pp. 162–163.
126 Fred B. Eiseman, Jr., *Bali: Sekala and Niskala: Essays on Religion, Ritual, and Art*, Periplus Editions, Watsonville, CA, 1990, p. 229.
127 Joseph Campbell, *The Power of Myth*, with Bill Moyers, Doubleday, New York, 1988, p. 215.
128 Daniel Quinn, "The New Renaissance," address delivered to the University of Texas Health Science Center at Houston, March 7, 2002.
129 http://clinton2.nara.gov/PCSD/Publications/TF_Reports/pop-intr.html.
130 Janine M. Benyus, *Biomimicry: Innovation Inspired by Nature*, Harper Perennial, New York, 2002, p. 18.
131 Ibid.
132 Jared Diamond, "What's Your Consumption Factor?" *New York Times*, January 2, 2008, p. 2, cited at: http://www.nytimes.com/2008/01/02/opinion/02diamond.html.
133 Natural Resources Defense Council (NRDC), *Transportation—Steps Back, Environment and the 106th Congress*, February 2001, http://www.nrdc.org/legislation/record/chap1.asp.
134 "What's Your Consumption Factor?" op. cit., p. 2.
135 *Ancient Futures*, op. cit., p. 145.
136 Fen Montaigne, "Global Fish Crisis," *National Geographic*, April 2007, p. 51.
137 *The Secret History of the American Empire,* op. cit., pp. 48–49.
138 http://www.solarenergy.org/resources/energyfacts.html. Source cited: *American Almanac*.
139 Paul Harrison and Fred Pearce, *American Association for the Advancement of Science Atlas of Population & Environment*, AAAS, Washington, D.C., 2000, http://atlas.aaas.org/index.php?part=2&sec=natres.
140 Ibid.
141 Ibid.
142 http://www.weyerhaeuser.com/ourbusinesses/forestry/timberlands/sustainableforestry.
143 Jean Giono, *The Man Who Planted Trees*, Chelsea Green, Chelsea, VT, 1985, (originally published in *Vogue* under the title "The Man Who Planted Hope and Grew Happiness," 1954), p. 25.
144 Ramona Peters, homepage for "The Wampanoag, People of the First Light," at the website of the Children's Museum, Boston, 2003, cited in Peter C. Stone, *Sanctuaries*, Writer's Collective, Providence, 2003, p. 11.
145 Thomas Berry, "Singing to the Dawn: Thomas Berry on Our Broken Connection to the Natural World," interview by Derrick Jensen, *The Sun*, May 2002, p. 8.
146 *A Dictionary of Symbols*, op. cit., p. 66.
147 *The Teaching of Buddha*, Bukkyo Dendo Kyokai, Tokyo, Japan, 1966, revised edition, 1992, p. 79, chapter 3: Part III.
148 http://www.chelseagreen.com/2006/items/zeriset.
149 Ibid.
150 Gunter Pauli, *The Zeri Educational Initiative*, http://www.zeri.org/initiative/concept.htm.
151 Ibid.
152 "The Village That Could Save the Planet," op. cit.
153 *The Historical Atlas of World Mythology, Part 2*, op. cit., p. 251.
154 Colin F. Taylor, *The American Indian*, Salamander, London, 2002, p. 15.
155 Herbert Spencer Robinson and Knox Wilson, *Myths & Legends of All Nations*, Bantam, 1950, p. 279.
156 Barry Holstun Lopez, *River Notes: The Dance of Herons*, Avon, New York, 1979, p. 38.
157 *Dictionary of Symbolism*, op. cit., pp. 381–382.
158 http://www.envirotools.org/factsheets/phytoremediation.shtml.
159 Ibid.
160 *Gaviotas: A Village to Reinvent the World*, op. cit., p. 13.
161 Daniel Quinn, *Ishmael*, Bantam/Turner, New York, 1992, p. 207.
162 *The Ecology of Commerce*, op. cit., p. 6.
163 *The Soul Would Have No Rainbow If the Eyes Had No Tears*, op. cit., p. 110.
164 *The Tarot Handbook*, op. cit., p. 281.
165 *Book of Camarthan*, ancient Welsh, cited in *The Essential Mystics*, op. cit., p. 4.
166 *Dictionary of Symbolism*, op. cit., pp. 381–382.
167 *A Dictionary of Symbols*, op. cit., p. 238.
168 *Dictionary of Symbolism*, op. cit., p. 243.
169 *Biomimicry*, op. cit., p. 39.
170 Ibid.
171 Ibid., p. 40.

172 Ibid., pp. 37–39.

173 Ibid., p. 43.

174 http://www.arborday.org/programs/NationalTree.

175 Meaning "People Building a Long House," the name for the People of the Six Nations (the Mohawks, Oneidas, Onondagas, Cayugas, Senecas, and later, the Tuscaroras) comprising what is referred to as the "oldest living *participatory* democracy on earth." See http://www.ratical.org/many_worlds/6Nations/index.html.

176 Oren Lyons, cited in *The Essential Mystics*, op. cit., p. 15.

177 *Dictionary of Symbolism*, op. cit., p. 225.

178 *Gaviotas: A Village to Reinvent the World*, op. cit., p. 8.

179 *The Sacred Pipe*, op. cit., p. 80.

180 *The Power of Myth*, op. cit., pp. 24–29.

181 *The Four Insights*, op. cit., p. 17–18.

182 Carol Jacobs, Cayuga Bear Clan Mother, *Presentation to the United Nations July 18, 1995*, http://www.ratical.org/many_worlds/6Nations/PresentToUN.html, reproduced from *Akwesasne Notes New Series*, Fall, 1995, Volume 1 Nos. 3 and 4, pp. 116–117.

183 *The Tarot Handbook*, op. cit., p. 281.

184 http://www.abundantforests.org/abundant.html, cited in *Forest Resources of the United States, 2002*, op. cit.

185 Douglas H. Chadwick, "The Truth About Tongass," in *National Geographic*, Washington, D.C., July 2007, p. 117.

186 David Quammen, "The Future of Parks: An Endangered Idea," *National Geographic*, October 2006, p. 62.

187 Natural Resources Defense Council, "The Bush Record," www.nrdc.org/bushrecord/default.asp, 2006.

188 Robert Redford, Board of Trustees, Natural Resources Defense Council, "A Message from Robert Redford About the Arctic Refuge," biogemsdefenders@savebiogems.org, January 11, 2005.

189 Sarah Bright and Stephen Mills, "Return of the Wildlands Auction Scheme," *Nature's Voice*, Natural Resources Defense Council, May/June 2007.

190 http://www.theodoreroosevelt.org/life/conNatlForests.htm.

191 "The Future of Parks: An Endangered Idea," op. cit., p. 63.

192 Stephen Miller, *The Economic Benefits of Open Space*, a study supported by selected Maine land trusts and the Maine Chapter of the Nature Conservancy, May 11, 1992, p. 7.

193 Ibid., p. 22.

194 *Qur'an*, 10:31.

195 Maori proverb, carving, Otago Plains, South Island, New Zealand.

196 Cree Prophecy, Pearls of Wisdom, http://www.sapphyr.net/natam/, Native American wisdom.

197 A. Sensier and P. Mantz, *Jean-Francois Millet: Peasant and Painter*, translated by H. de Kay, J. R. Osgood, Cambridge, MA, 1881, p. 120.

198 *The Four Insights*, op. cit., p. xiv.

199 Jack Tresidder, *1,001 Symbols: An Illustrated Guide to Imagery and Its Meaning*, Chronicle, San Francisco, 2004, p. 306.

200 Joseph [Hinmaton Yalatkit], cited in *Native American Wisdom*, op. cit., p. 95.

201 *Reflections on the Art of Living*, op. cit., p. 185.

202 http://www.epa.gov/superfund/sites/index.htm.

203 http://www.sierraclub.org/toxics/superfund/report04/.

204 Ancient Indian Proverb, http://www.niehs.nih.gov/kids/quotes/qtamind.htm, National Institute of Environmental Health Sciences (NIEHS), June 8, 2005.

205 *Tao Teh Ching*, op. cit., chapter 64.

206 *Dictionary of Symbolism*, op. cit., p. 208.

207 A Pueblo Indian Prayer, Pearls of Wisdom, http://www.sapphyr.net/natam/, Native American wisdom.

208 *The Man Who Planted Trees*, op. cit., p. 18.

209 http://www.geocities.com/gbmovement/.

210 *The Secret History of the American Empire*, op. cit., pp. 181–182.

211 *Biomimicry*, op. cit., p. 9.

212 Ibid., p. 1.

213 Jerry Sittser, *A Grace Disguised: How the Soul Grows Through Loss*, Zondervan, Grand Rapids, MI, 1995, p. 33.

214 *The Language of the Flowers*, op. cit., p. 16.

215 Ibid., p. 17.

216 *Dictionary of Symbolism*, op. cit., p. 381.

217 *The Language of the Flowers*, op. cit., p. 27.

218 Ibid., p. 20.

219 *River Notes*, op. cit., p. 5.

220 Rami M. Shapiro, *Wisdom of the Jewish Sages: A Modern Reading of Pirke Avot*, Bell Tower, New York, 1995.

221 Joel K. Bourne, Jr., "Green Dreams," *National Geographic*, October 2007, p. 41.

222 Frederik Balfour, "Understanding the Global Rice Crisis," *BusinessWeek*, 2008, http://www.businessweek.com/globalbiz/content/apr2008/gb20080428_894449.htm?chan=search, April 28, 2008.

223 Thomas Merton, "Symbolism: Communication or Communion?" *New Directions 20*, New Directions, New York 1968, pp. 11–2.

224 *Dictionary of Symbolism*, op. cit., p. 173.

225 *The Tarot Handbook*, op. cit., p. 225.

226 http://altreligion.about.com/library/glossary/symbols/bldefshexagram.htm, About, Inc., a part of the New York Times Company, 2008.

227 *Symbols of Native America*, op. cit., pp. 1641–165.

228 Peter Matthiessen, *The Snow Leopard*, Bantam, New York, 1978, p. 92.

229 *The Wise Garden Encyclopedia*, op. cit., p. 548.

230 *Dictionary of Symbolism,* op. cit., pp. 871–88.

231 http://painting.about.com/cs/inspiration/a/symbolsflowers.htm.

232 Thomas, Pakenham *Remarkable Trees of the World*, W.W. Norton & Co., New York, 2002, p. 57.

233 *Dictionary of Symbolism,* op. cit., p. 302.

234 *Shamanism*, op. cit., p. 121.

235 Norman Maclean, *A River Runs Through It*, Pocket Books, New York, 1992, p. xiv.

236 *Symbols of Native America*, op. cit., p. 288–289.

237 *Dictionary of Symbolism,* op. cit., pp. 87–88.

238 *The Works of Leonardo Da Vinci: Selections from the Original Manuscripts, Philosophical Maxims,* (publication date obscured), p. 238, #1144, cited in *The Notebooks of Leonardo da Vinci*, edited by Jean Paul Richter, 1880.

239 C. G. Jung, *The Meaning of Psychology for Modern Man: Civilization in Transition*, cited in *The Collected Works of C.G. Jung*, Vol. 10, Bollingen Foundation, New York, 1964, p. 144.

240 *Reflections on the Art of Living,* op. cit., p. 123.

241 Ibid., p. 133.

242 John G. Neihardt, *Black Elk Speaks*, University of Nebraska Press, 1961, p. 198–199.

243 *The Gospel of Sri Ramakrishna*, translated by Swami Nikhilananda, copyright 1942, Ramakrishna-Vivekananda Center, New York, 1969, p. 85.

244 *Wisdom of the Jewish Sages*, op. cit., *Pirke Avot* 4:22.

245 *The Teaching of Buddha*, op. cit., chapter 3: Part I, 5. p. 70.

246 Llyn Roberts, *The Good Remembering: A Message For Our Times*, O Books, Winchester, U. K.; New York, 2007, p. 59.

247 *Symbols of Native America*, op., cit., p. 25.

248 *The Power of Myth*, op. cit., p. 109.

249 *Symbols of Native America*, op. cit., pp. 216–217.

250 Ibid., pp. 200–201.

251 *The American Indian*, op. cit., p. 59.

252 Ibid., p. 85.

253 Ibid., p. 341.

254 *The Power of Myth*, op. cit., pp. 78–79.

255 *Reflections on the Art of Living*, op. cit., p. 184.

256 *The Bhagavad Gita*, op. cit., p. 42.

257 Ibid., ch. 17: v. 3.

258 Proverbs 23:7, King James Bible.

259 *Brihadaranyaka Upanishad, The Upanishads*, op. cit., p. 48, IV:v;6.

260 *The Secret History of the American Empire*, op. cit., p. 108.

261 Ibid.

262 *The Soul Would Have No Rainbow if the Eyes Had No Tears*, op. cit., p. 53.

263 *The Dhammapada*, ch. 1: v. 1.

227 *Symbols of Native America*, op. cit., pp. 1641–165.

228 Peter Matthiessen, *The Snow Leopard*, Bantam, New York, 1978, p. 92.

229 *The Wise Garden Encyclopedia*, op. cit., p. 548.

230 *Dictionary of Symbolism,* op. cit., pp. 871–88.

231 http://painting.about.com/cs/inspiration/a/symbolsflowers.htm.

232 Thomas, Pakenham *Remarkable Trees of the World*, W.W. Norton & Co., New York, 2002, p. 57.

233 *Dictionary of Symbolism,* op. cit., p. 302.

234 *Shamanism*, op. cit., p. 121.

235 Norman Maclean, *A River Runs Through It*, Pocket Books, New York, 1992, p. xiv.

236 *Symbols of Native America*, op. cit., p. 288–289.

237 *Dictionary of Symbolism,* op. cit., pp. 87–88.

238 *The Works of Leonardo Da Vinci: Selections from the Original Manuscripts, Philosophical Maxims,* (publication date obscured), p. 238, #1144, citcd in *The Notebooks of Leonardo da Vinci*, edited by Jean Paul Richter, 1880.

239 C. G. Jung, *The Meaning of Psychology for Modern Man: Civilization in Transition*, cited in *The Collected Works of C.G. Jung*, Vol. 10, Bollingen Foundation, New York, 1964, p. 144.

240 *Reflections on the Art of Living,* op. cit., p. 123.

241 Ibid., p. 133.

242 John G. Neihardt, *Black Elk Speaks*, University of Nebraska Press, 1961, p. 198–199.

243 *The Gospel of Sri Ramakrishna*, translated by Swami Nikhilananda, copyright 1942, Ramakrishna-Vivekananda Center, New York, 1969, p. 85.

244 *Wisdom of the Jewish Sages*, op. cit., *Pirke Avot* 4:22.

245 *The Teaching of Buddha*, op. cit., chapter 3: Part I, 5. p. 70.

246 Llyn Roberts, *The Good Remembering: A Message For Our Times*, O Books, Winchester, U. K.; New York, 2007, p. 59.

247 *Symbols of Native America*, op., cit., p. 25.

248 *The Power of Myth*, op. cit., p. 109.

249 *Symbols of Native America*, op. cit., pp. 216–217.

250 Ibid., pp. 200–201.

251 *The American Indian*, op. cit., p. 59.

252 Ibid., p. 85.

253 Ibid., p. 341.

254 *The Power of Myth*, op. cit., pp. 78–79.

255 *Reflections on the Art of Living*, op. cit., p. 184.

256 *The Bhagavad Gita*, op. cit., p. 42.

257 Ibid., ch. 17: v. 3.

258 Proverbs 23:7, King James Bible.

259 *Brihadaranyaka Upanishad, The Upanishads*, op. cit., p. 48, IV:v;6.

260 *The Secret History of the American Empire*, op. cit., p. 108.

261 Ibid.

262 *The Soul Would Have No Rainbow if the Eyes Had No Tears*, op. cit., p. 53.

263 *The Dhammapada*, ch. 1: v. 1.

For information about the author, visit

www.petercstonestudios.com.